IMAGES OF ENGLAND

BIRMINGHAM
1900–1945
A SOCIAL HISTORY
IN POSTCARDS

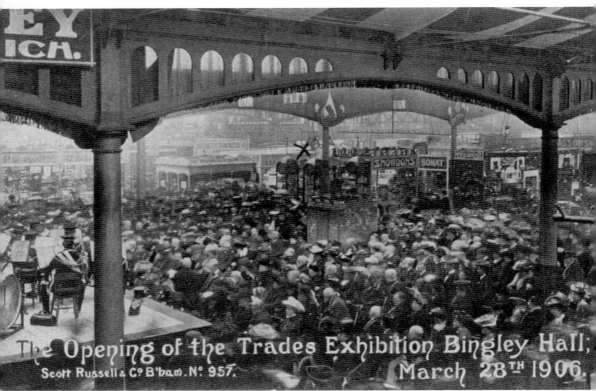

The Opening of the Trades Exhibition Bingley Hall,
March 28TH 1906.

Scott Russell & Cº B'ham. Nº 957.

IMAGES OF ENGLAND

BIRMINGHAM
1900–1945
A SOCIAL HISTORY
IN POSTCARDS

ERIC ARMSTRONG

TEMPUS

Frontispiece: 'Bang the drum for Brum', a city never slow to display to the world its ability to manufacture desirable products and to stage general trade exhibitions. Firms exhibiting here include: Ardath Tobacco Co., London; Snowdons; Sonat. Someone's 'delicious jelly' is also advertised. For many years, Bingley Hall, off Broad Street and near the city centre, served as Birmingham's premier location for a major celebration or exhibition. For example, in 1931 the Birmingham Co-op celebrated its Golden Jubilee in this hall (see p.35).

First published 2006

Tempus Publishing Limited
The Mill, Brimscombe Port,
Stroud, Gloucestershire, GL5 2QG
www.tempus-publishing.com

British Library Cataloguing in Publication Data.
A catalogue record for this book is available from the British Library.

ISBN 0 7524 4037 3

Typesetting and origination by Tempus Publishing Limited.
Printed in Great Britain.

Contents

Acknowledgements

In carrying out the research for this book I warmly acknowledge the help I have received from the following sources:

Allen, Tony, 'Women at War 1914-1918', Great War History – No. 14, (Tony Allen, 2002)
Bradnock, F.W., *City of Birmingham Handbook 1947*, (Birmingham Corporation, 1947)
Cadbury Brothers Ltd, *Bournville 1925 Transport*, (Cadbury Brothers Ltd, 1925)
Cadbury Brothers Ltd, *Our Birmingham*, (Cadbury Brothers Ltd, 1943)
Chew, Linda and Anthony, *The Co-op in Birmingham*, (Tempus, 2003)
Harding, Mary, *Birmingham Hospitals*, (Reflections of a Bygone Age, 1999)
Harrison, Derek, *Salute to Snow Hill*, (Barbryn Press, 1978)
Marks, John, *Birmingham Shops*, (Reflections of a Bygone Age, 1997)
Marwick, Arthur, *Women at War 1914-1918*, (Fontana, 1977)
McKenna, Joseph, *Birmingham as it Was: The City 1857-1914*, (Birmingham Public Libraries, 1984)
Moore, Ronald K., *Up the Terrace Down Aston and Lozells*, (Westwood Press, 1993)
Price, Victor J., *Handsworth Remembered*, (Brewin Books, 1992)
Rogers, Gareth, *Fleet and Free – A History of Birchfield Harriers Athletics Club*, (Tempus, 2005)
Shill, Ray, *Birmingham Industrial Heritage 1900-2000*, (Sutton Publishing, 2002)
Zuckermann, Joan and Eley, Geoffrey, *Birmingham Heritage*, (Croom Helm, 1978?)

I am particularly grateful to Dalkeith Postcards for their permission to reproduce copyright material.

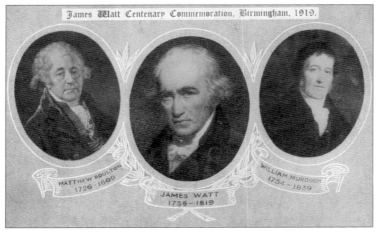

James Watt Centenary Commemoration, Birmingham, 1919.

MATTHEW BOULTON 1726-1809

JAMES WATT 1736-1819

WILLIAM MURDOCH 1754-1839

Through their individual and combined abilities, these three highly talented and industrious men played major roles in helping to place Birmingham on the map, and to develop Britain as the leading industrial nation in the world.

Introduction

The aim of this book is to illustrate and comment on life in Birmingham during the period 1900 to 1945. The 'way ahead' is signalled by the chapter titles.

In order to place the Birmingham experience in a broader context, a very brief history of Britain 1900–1945 now follows.

In 1900, British people accepted, as part of the natural order of things, that their country governed a worldwide empire, numbering by 1920 some 600 million people. During the 1920s pressure mounted from parts of the Empire for greater independence from the mother country. By 1931 Australia and Canada had become dominions with improved self-governing powers. The pressure process continued.

The British people were also governed from London and they too pressed for more power to be passed to the people. But universal suffrage was only gradually and grudgingly conceded. The combination of suffragette agitation and general recognition of the invaluable contribution made by women to the successful war effort brought, in December 1918, votes for women aged thirty and over. Another ten years passed before that age was reduced to twenty-one, the same as for men.

The political landscape also changed. In 1906 the Labour Party was formed, with strong trade union backing. The party grew, achieving mixed success, but in 1940 was strong enough to form an essential part of a coalition government.

The inter-war period was periodically scarred by civil unrest. The root causes of bitter strikes and mass protests lay far less in ideological beliefs than in poverty, hunger and unjust power.

'A country fit for heroes to live in' was the resounding promise made by the prime minister Lloyd-George to those who had survived the carnage and horrors of the First World War. But economic depression and rising unemployment set in. Wages were slashed. In 1921, 2.2 million people were unemployed. Wounded ex-servicemen could be seen on city streets peddling matches and bootlaces from trays slung from their necks. Welsh miners marched 180 miles to London to protest against their communities' impoverished lives. Miners en masse united behind their slogan 'Not a penny off the pay, not a second on the day'. 1926 brought the General Strike which nearly toppled the government.

Various governments had introduced palliative measures to ease economic distress but unemployment pay, a pittance, was deeply resented by those in the dole queue, linked as it was to a demeaning means test.

But whatever the state of the nation, the levels of individual incomes and the nature of individual political beliefs, people buckled down to everyday living, to humdrum perhaps but essential activities like earning a crust whenever possible, catching a tram or bus to work, shopping, visiting a relative in hospital, trudging to school, having a bit of fun – now and then.

Life remained tough for many people, especially those who depended on the weekly 'help' of pawnbrokers. But improvements did come along, many being of a technical nature. For

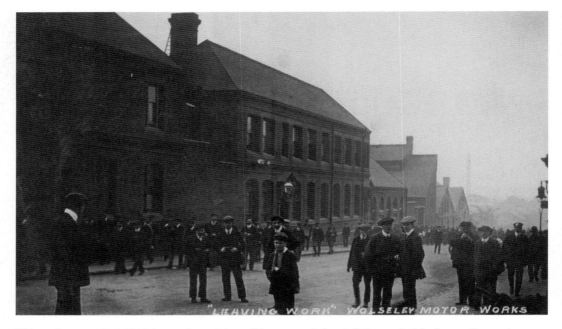

This card, postmarked 1910, is one that might well have appealed to L.S. Lowry, had he been a Brummie. Wolseleys main factory was located at Adderley Park. In 1905, one Herbert Austin left this firm to set up his own factory in Longbridge. Although the bulk of their production consisted of motor cars, Wolseleys also produced commercial vehicles. The flat cap, collar and tie fashion (almost a uniform) for shopfloor working men is highly characteristic of the time.

example, fragile gas mantles and fiddling adjustments to the gas supply became things of the past. Move a switch and, by the invisible magic of electricity, a bulb lights up in the kitchen where you could also even cook with electricity, and get warmth from an electric fire.

Now and then something would happen to prompt a whistle of surprise, followed by 'whatever next?' and animated discussion about popular topics such as that nice Mr Austin ('Bunny') who had quit the long-trousered brigade to wear white shorts at Wimbledon!; the phenomenal football transfer fee of £13,000!; the behaviour of Mae West on and off the screen!

Rapid developments in radio and cinema technology greatly enriched news and views transmissions and, most particularly, popular entertainment. Similarly, improvements to the internal combustion engine vastly facilitated car, bus, coach and even aircraft journeys that earlier generations could only have dreamt about.

So, despite gathering war clouds, by 1939 life for the man-in-the-street and his family had bucked up quite a bit. Employment and earnings were rising, political extremism was waning (in Britain) and the national mood was one of quiet determination to cope with whatever trials lay ahead. The mass evacuation of children from towns thought to be likely air-raid targets was successfully carried out and the nation 'just got on with it', i.e. winning the war. Once the war in Europe was won, a General Election was held in July 1945. The results astounded most people: Labour 393 seats, Conservatives 213, Liberals 12 and the Independents 22. The British people deeply desired a government and society greatly different in character from that of 1918. In an exhausted and impoverished country, the wheels were set in motion to bring into operation a comprehensive welfare state.

one

Earning a
Living I

By the end of the nineteenth century, Birmingham had become a major industrial city, having deservedly earned the reputation, expressed in workaday terms, of being 'the workshop of the world' and 'the city of 1,001 trades'. Relatively few homes in this country would be without some article, often a metal one, that did not have 'Made in Birmingham' stamped upon it. Much of the city's economic strength and resilience derived from its skilled workforce, ranging from silversmith to gunsmith and including toolmakers and patternmakers, turners and millwrights. The diversity of product range and workforce composition were major factors enabling the city to work its way out of economic depression rather more quickly than communities highly dependent on a few trades, like shipbuilding and coal mining.

Previous page: This inter-war scene at Belliss & Morcam could well represent Birmingham's 'metal-bashing' tradition (see also p.15).

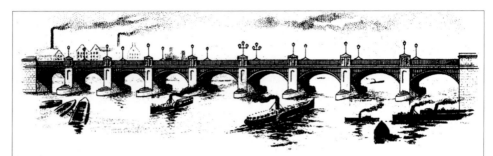

NEW VAUXHALL BRIDGE LONDON

The whole of the CAST STEEL BEARINGS for the above Bridge are by

KYNOCH LIMITED,
STEEL FOUNDERS,
WITTON, BIRMINGHAM.

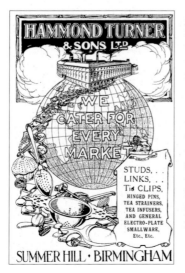

Above: Getting known – in heavy metal and in light. It pays to advertise and to publicise – whatever the size, shape and weight of your metal product, and whatever the metal employed. Such seems to be the belief of these two firms, and no doubt many others. More appears about Kynoch on pages 112 and 113.

Left: The list of Hammond Turner products (postmarked *c.* 1922) provides an interesting insight into menswear fashion of the 1920s and '30s. 'Studs' almost certainly refers to collar studs, front and back, for detachable shirt collars. 'Cufflinks' were worn by wearers of better-quality shirts, the best set being picked out for social occasions. 'Tie clips' and tie pins, produced in a great variety of designs, made pleasing objects for presents, as did cufflinks.

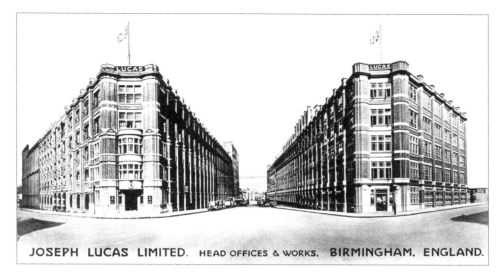

JOSEPH LUCAS LIMITED. HEAD OFFICES & WORKS. BIRMINGHAM, ENGLAND.

Above and below: Two of Birmingham's largest employers both engaged in electrical engineering. From cycle lamp making in the last two decades of the nineteenth century, Joseph Lucas branched out into the manufacture of electrical components for cycles and motor vehicles. Starting in Little King Street, a larger factory was built later in Great King Street, as illustrated. By extending its range of activities and acquiring more factories, Joe Lucas became, during the 1930s, the largest firm in the world supplying lighting sets and magnetos for motor vehicles and cycles. 'King of the Road 1879-1940' was the slogan above illustrations of their bicycle products on a full-page advertisement in the magazine *Cycling*, 3 January 1940.

The switch from steam power to electricity generated a widespread and heavy demand for electrical goods of all kinds. GEC, which came to Witton in 1900, became a major supplier to the new demand for electric generators and electric motors. New power stations were springing up at home and abroad. The large, virtually triangular site at Witton was bounded by a canal, a railway and a wide drive known as 'Electric Avenue', nicely symbolic of an industrial age.

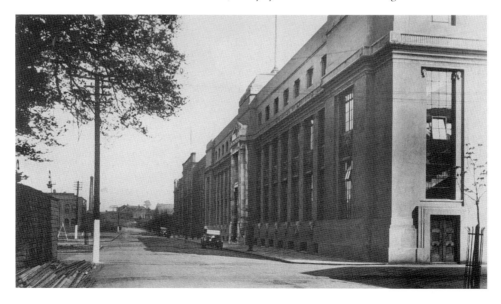

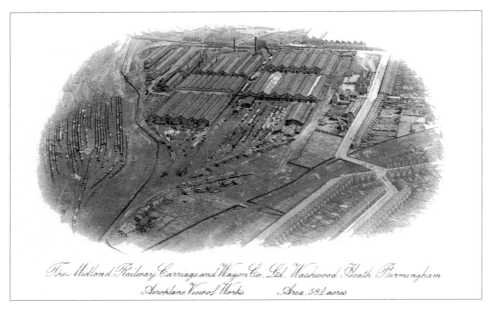

The Midland Railway Carriage and Wagon Co. Ltd. Washwood Heath Birmingham
Aeroplane View of Works Area. 58¼ acres

Although not the clearest of cards, the large size of the factory can be identified readily enough. Originating in the early days of the railways (1840s) the company moved into this purpose-built factory in 1912. The purpose? To build wooden wagons and coaches for the railways. Although working in wood was its specialism, the factory housed a smithy for forging and shaping metal parts including axles and wheels.

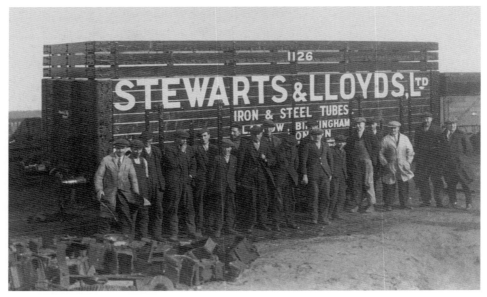

This hefty wooden wagon may have been built by the company illustrated above? The metal tubes produced by Stewarts & Lloyds were used in all manner of industries not least those concerned with gas and water distribution. The three partly concealed locations are almost certainly Glasgow, Birmingham and London.

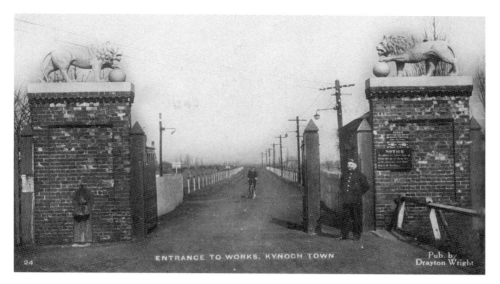

ENTRANCE TO WORKS, KYNOCH TOWN

Pub. by Drayton Wright

'No matches are allowed inside the works. Anyone having them in their possession must hand them to the gatekeeper.' So, apparently, runs the lower notice by the gatekeeper on duty when this photograph was taken. Kynochs at the Lion Works, Witton was one of the city's largest employers. But 'Town'? Probably tongue-in-cheek hyperbole. During two world wars this factory produced massive quantities of munitions (see also pp 112, 113). On this site, the firm was also concerned with the production and working of high-grade metals in strip, sheet, wire and rod forms. Kynochs eventually became part of ICI Metals.

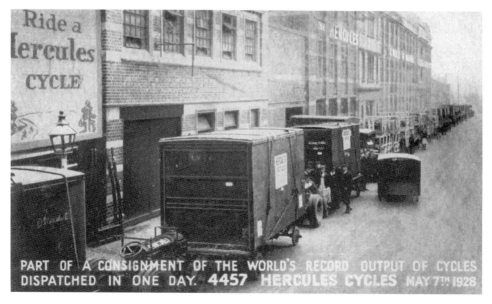

Ride a Hercules CYCLE

PART OF A CONSIGNMENT OF THE WORLD'S RECORD OUTPUT OF CYCLES DISPATCHED IN ONE DAY. 4457 HERCULES CYCLES MAY 7TH 1928

'By 1900 Birmingham had the largest number of cycle-makers and component manufacturers in Britain.'★ By using mass-production processes at Rocky Lane, Aston Hercules reached the output shown on the card. By 1939, six million cycles had been built. 'The company was now the largest cycle manufacturer in the world with one-third of their output being exported.' ★ (★Ray Shill)

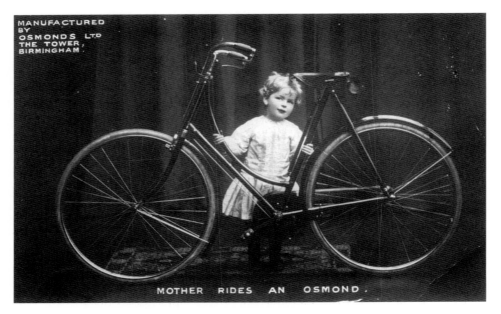

On a less Herculean scale was Osmonds, a firm that also manufactured motorcycles. The use of a winsome little girl to promote what is obviously a lady's bike (no crossbar) is an imaginative touch. Standard accessories include a pump and rather petite saddlebag. Although the gear wheel is encased, the rest of the chain is not – and this was a period of long skirts. (Postmarked 1905.) The front mudguard finishes at the front fork and the brake levers seem the opposite way round from what became customary. 'The Tower' was a Sparkbrook address.

The back of this promotional card reads, in part: 'Selly Oak, March 1924. Dear Sir, "Endless" Rims are used by nearly all the important Manufacturers in the Trade. You, like them, will find "Endless" Rims easy to trim up, and make a perfect Wheel...' ('Can't see the join' did someone say?)

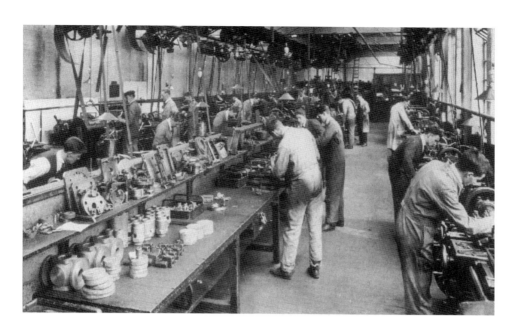

A study of concentration on the job in hand at Belliss & Morcam, a major engineering firm operating on several Birmingham sites. The company manufactured quality steam turbines and air compressors. Overhead shafting, belt and pulley drives as the source of localised power would be found in hundreds of Birmingham factories.

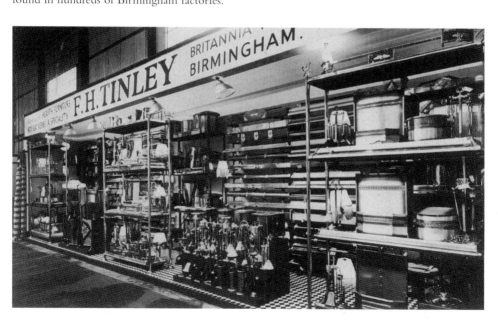

Most homes in Britain burned coal on open fires for warmth. Birmingham firms seized the opportunity to manufacture the proper tools for tending such fires. Many such appliances as seen here, bottom right, consisted of four tools hanging from a stand: a short poker, a pair of tongs, a dustpan and a brush. This allowed plenty of scope for variations in design and for the production of accessories like fenders, guards and boxes for coal storage doubling as fireside seats.

Left: A handpress of a kind in widespread use. Presses of various designs and sizes were manufactured according to the types of metal to be 'bashed'.

Below: Is there anything more aromatically mouth-watering than the baking of bread? Residents in and around Finch Road, Lozells/Handsworth and people passing by at baking time, would sniff the air like entranced Bisto Kids. Baines' issued several promotional cards, being one of a number of bakeries in the city to provide the Birmingham Co-op with some competition.

Opposite below: As a major Birmingham firm employing not hundreds but thousands of workers at Bournville alone, Cadburys documented and illustrated its history in a variety of ways. This illustration is one of many such promotional cards. Issued in the 1920s, it appears as an enlarged double-page centre spread in *Bournville 1925 Transport* and plainly demonstrates the factory in a garden concept and the fact that Bournville has its own railway marshalling yard. (Continued on p.18.)

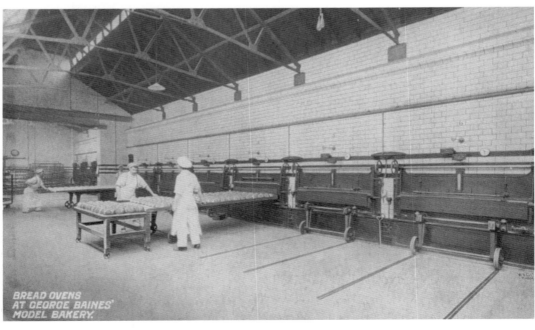

BREAD OVENS
AT GEORGE BAINES'
MODEL BAKERY.

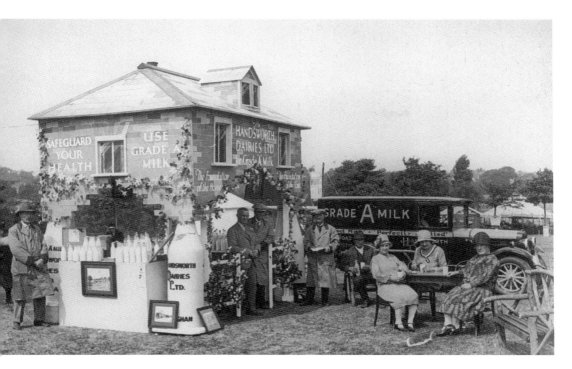

Above: While Birmingham Co-op was probably the largest milk supplier, several other quite sizeable dairies operated successfully in the city. Handsworth Dairies on Island Road was one of these. This card, one of several similar, records a promotional 'stand', quite possibly in Handsworth Park at the city's annual flower show.

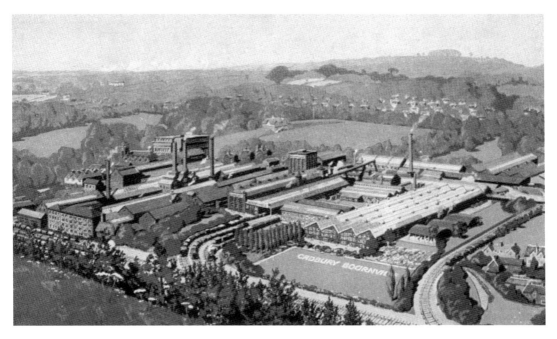

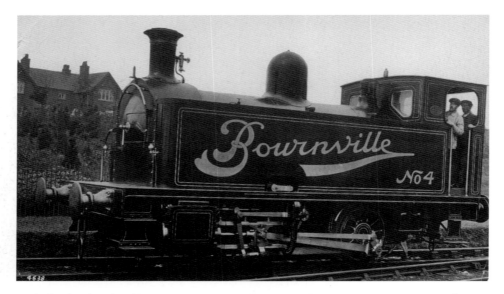

In the book referred to on page 16, a section is devoted to 'The Sidings System' at Bournville, including a sketch plan of the layout. Salient features include '4½ miles of single track' – linked to the main line. ' …it is thus possible for full trains to be received from the railway company at practically any time of the day, and without interference with outgoing traffic. For shunting purposes within the siding four steam locomotives are used.'

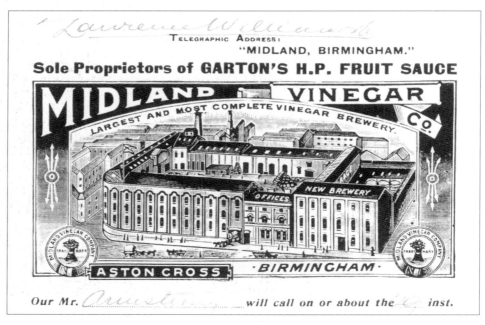

Close by Ansells, a major Birmingham brewery, HP sauce offered its own distinctive aroma to an already 'interesting' atmosphere. HP, of course, stands for 'Houses of Parliament'. The representative who is to call on a Brighton customer, is, so far as is known, unrelated to the author who is certainly partial to HP's brown sauce.

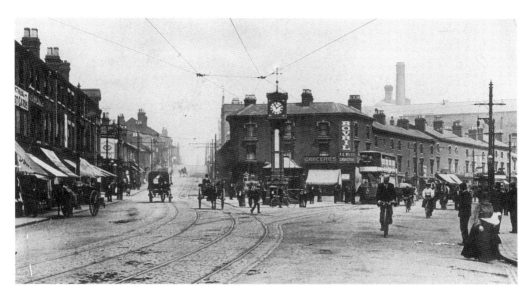

Postmarked 1907 this card shows Ansells Brewery, background right. Park Road lies to the left and Lichfield Road to the right. Between them Ansells and Mitchells & Butlers (M&B) came to dominate the brewing business in Birmingham and district. The clock tower replaced an earlier cross that had marked the entrance to the estates of the Holte family, of Aston Hall connections.

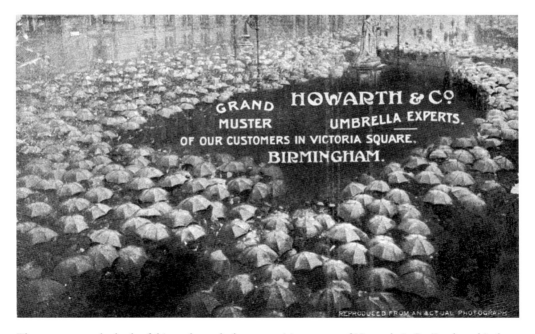

The message on the back of this card reveals the enterprising nature of Howarth & Co. 'Look at this show of umbrellas, I think they must have assembled at the unveiling of King Edward's statue in the Square' (Victoria) 'expect it was taken from ? window.' A different card showing the unveiling confirms that surmise. The card shown also provides a clue, bottom right. This firm also published a number of joky cards on the theme of umbrellas. The firm was located in Bull Street – a street where Cadburys originated.

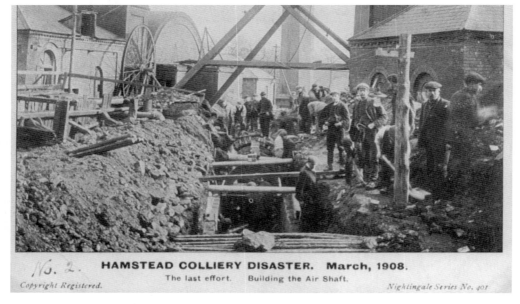

HAMSTEAD COLLIERY DISASTER. March, 1908.
The last effort. Building the Air Shaft.
No. 2.
Copyright Registered. Nightingale Series No. 401

While not generally associated with coal mining, Birmingham did have two pits near part of its northern perimeter, at Sandwell and at Hamstead. Like the public, postcard publishers showed great interest in disasters. The above disaster was no exception. The original owner of this card, as part of a longer account on related cards, writes: 'Then commenced the work of building the air shaft which lasted till Monday. Then one or two unsuccessful descents were made... the rescuers found 10 bodies. The work of rescue was continued... You will obtain the other facts from the cutting...' Twenty-five men and seventy-six pit ponies died.

A 'cutting' which may well have been taken from much earlier editions of one of these newspapers.

two

Earning a
Living II

RESCUE DRILL
DRAEGER BREAKING APPARATUS LIFE LINE
ASTON FIRE BRIGADE

Although the manufacturing industries probably constituted the major wealth producers of the city, to be successful they needed a supporting and efficient infrastructure. Some service suppliers became important employers, not least local government, in regard to blue and white collar workers. Gas, water and electricity services were in municipal ownership and under municipal control. The same held true of bus and tram services – and the city's airport at Elmdon which opened in 1939. But plenty of scope remained for private enterprise to provide services, e.g. motor repairs, laundries, hairdressers, shops of every kind and size, the railways, every type of entertainment and the press.

Previous page: Large suburbs like Aston and Handsworth had their own firemen and fire stations before being taken under the wing of a citywide organisation.

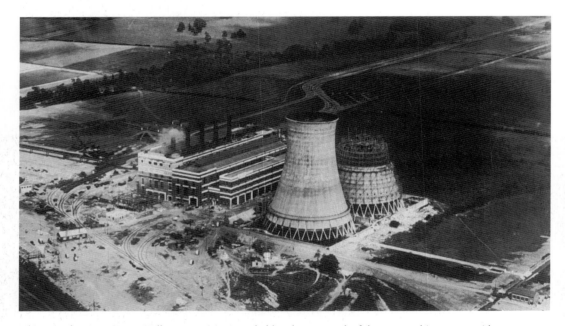

Above: At the time, Hams Hall power station was held to be a marvel of the age, evoking great pride among Brummies. Sited near Coleshill, the first part of the station was opened in 1929. By 1939, the number of ferro-concrete cooling towers had grown from two to six and the station's capacity from 90,000 to 240,000 kilowatts, increasing to around 500,000 in the early post-Second World War period. At this time, Birmingham Corporation could proudly claim its ownership of the 'largest Municipal Electricity Undertaking in the country'.

Opposite below: As the photographer has a Small Heath address, it is likely that this body of men constituted the Small Heath police force or part of a division including that suburb. The spiked helmets suggest that this is a pre-First World War card. In 1945, the authorised establishment for the city, 'specials' excluded, was 2,062 men and thirty-five women.

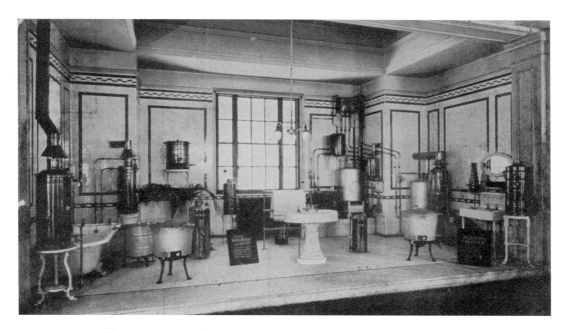

Above: Gas, like electricity, was also in municipal ownership and control. Gas was manufactured in four main works and gas showroom/offices were dotted about the suburbs, the main showroom, part of which is shown, being in the Council House. Hot water geysers are much in evidence and GEYSER can be made out on the blackboard. A step towards running hot water in the home.

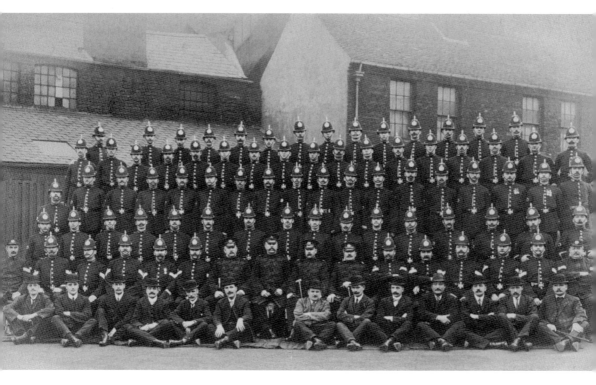

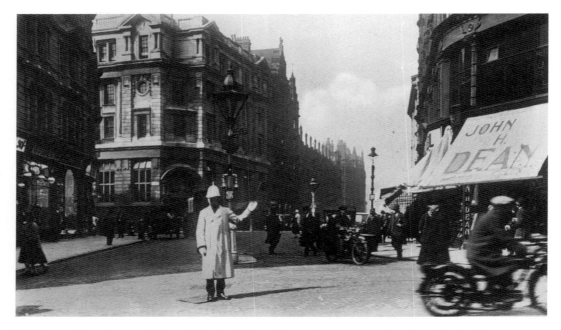

The law standing alone, probably early in the 1930s as the prestigious King Edward's High School building (demolished in 1936) can still be seen in the distance left. The motorcyclist is just entering High Street while the traffic cop is looking roughly in the direction of the Bull Ring.

Above: When this photograph was taken, Winson Green Prison had seen prisoners come and go for nearly eighty years. Built in castle-like form in 1849, when views on criminal justice could hardly be called liberal, the prison presented a forbidding sight to passers-by. Even the warders' cottages, close by, looked grim. Executions, by hanging, were carried out at this gaol.

Opposite below: This is the Upper Priory location. The successors of these firemen, operating from Lancaster Place, would have quite new hazards to face from air raids, especially from August 1940 onwards.

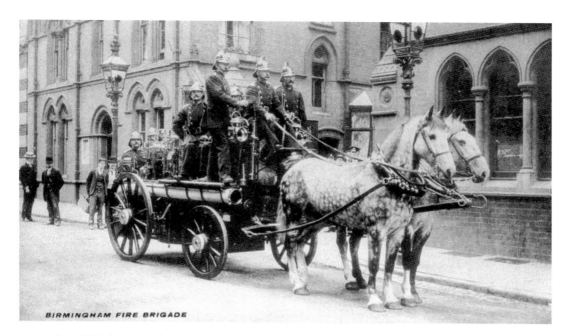

BIRMINGHAM FIRE BRIGADE

Above: This fire 'engine' must have made a thrilling sight when dashing full tilt to cope with what reporters would describe as a 'conflagration'. In 1883, Birmingham opened its first central fire station. Located in Upper Priory it was replaced by a new state-of-the-art station at Lancaster Place in the 1930s.

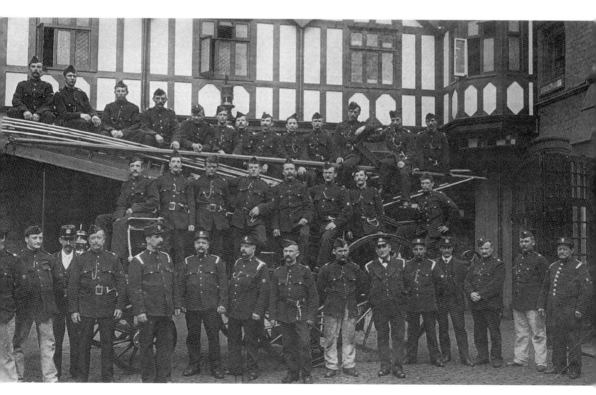

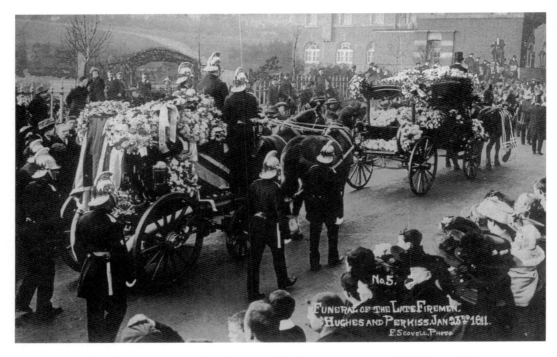

Above: Information gleaned from related cards suggests that these two men were killed in a training accident. The importance attached to funerals of this nature, pre-First World War, is strikingly demonstrated.

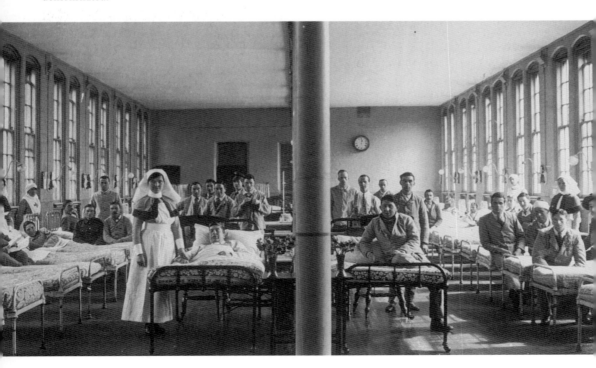

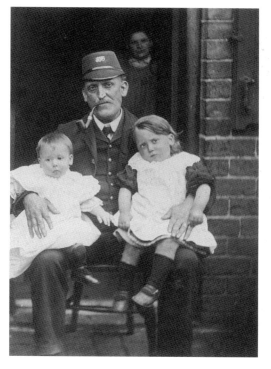

Right: The bag on the back of the door opens to reveal a concertina of ten views of Handsworth, Birmingham. Part of the message on the card's back reads: 'Dear Miss Paget, I was pleased to recieve your P.P.C. ...' The backs of many cards reveal that postcard sending was a pleasurable activity and postcard collecting, an emergent hobby. In this case, Dorothy, the sender, had been uncertain about the spelling of 'receive'.

Right: Is this postman, dressed in the manner of the artist's drawing, about to start his round? Or is he just unwinding a little after finishing for the day? The pipe seems to favour the latter explanation.

Opposite below: From the uniformity of dress of the patients and their youthful appearance, this hospital ward appears to be for servicemen wounded in the First World War. A pretty nurse holds the right hand of one of the patients, thereby giving a clue to the hospital's location. On the end of the lucky patient's mattress, these words can be made out: 'Birmingham Workhouse Infirmary'. This could mean that the ward is part of the Infirmary or that the mattresses have been loaned to another location. Either way, nurses are quite indispensable!

A sorting office, thought to be in Moseley, 1920. As could be expected, 'pigeonholes' are much in evidence. The hefty mailbags must have been quite a weight when full. Between the two sets of sacks hangs a bundle of what could be fastening material? Roughly equal lengths of coarse twine?

Above: Between the wars, the GPO experimented extensively with mechanical means for speeding up the sorting process. A combination of conveyors, chutes and keyboard methods of control were tried, with mixed success. This post office in Sutton New Road was built in 1934, in typical 1930s style.

Opposite below: Dating back to 1904, the popular Midland Red bus services both competed and collaborated with Birmingham Corporation buses. On certain routes, or sections of them, the public had the choice of a Midland Red bus or a Corporation one. Midland Red services commonly travelled in all directions beyond the city's boundaries. One example is shown right, Studley being some sixteen miles south of the city centre.

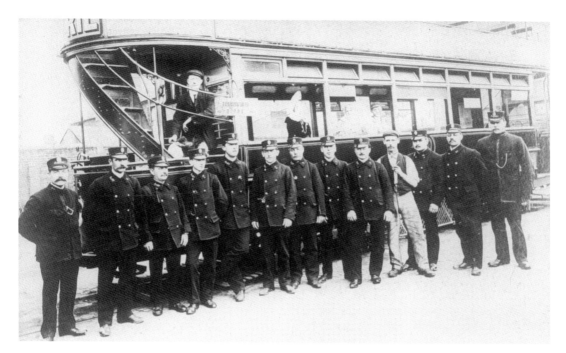

Above: By the man standing on the staircase the sign reads: 'Handsworth Depot'. Between 1904 and 1911 Birmingham Corporation took over the running of tramway services which became a major source of employment. Although trams were steadily superseded by Corporation buses at the end of the Second World War, 430 trams were still running compared with 1,100 buses. At that time, the Department of Transport employed some 9,000 people, a little over 800 who were tram drivers.

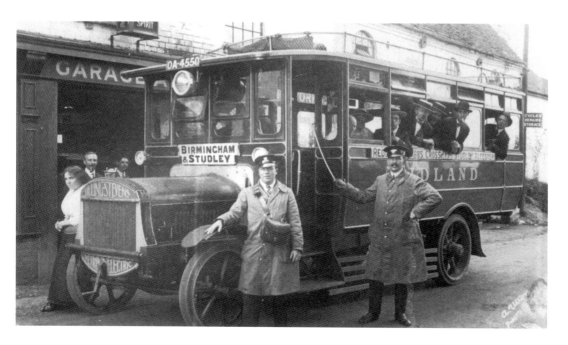

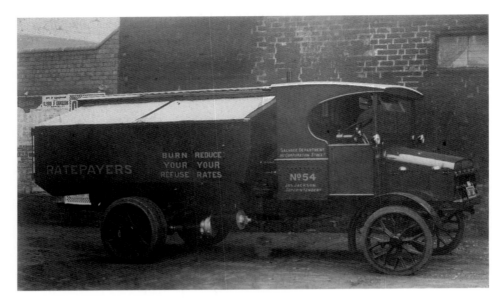

This municipal dustcart and its companion vehicles were managed by the Corporation Salvage Department located at 161 Corporation Street, Jas Jackson being the Superintendent at the time this card was published. Locally, the carts operated from a number of suburban depots. At the time, public policy encouraged the burning of waste. Even in 1945 municipal destructors incinerated whatever was left from salvage operations. Before the Second World War, much of the resultant clinker was used in road construction. Refuse was regularly collected (c. 1945) from some 300,000 premises.

The suburban railway station of Selly Oak is evidently well manned: a stark contrast to the impersonal, ghost-like stations of the early twenty-first century. The letters MR can be seen on the peaks of the caps of some of the staff. This station served the LMR line running north into the city centre and south to Bournville and beyond.

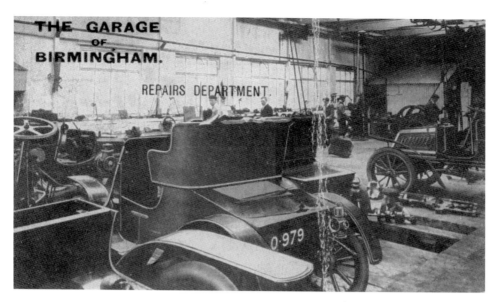

Located in Stephenson Street, near New Street Station, this spacious repair garage in the city centre reflects something of the growth in motor car traffic, and the need for the relatively new trade of motor mechanic to expand. One such mechanic can be seen in the inspection pit wearing the customary cloth cap and waistcoat. It would be rare, at that time, for an employer to provide overalls.

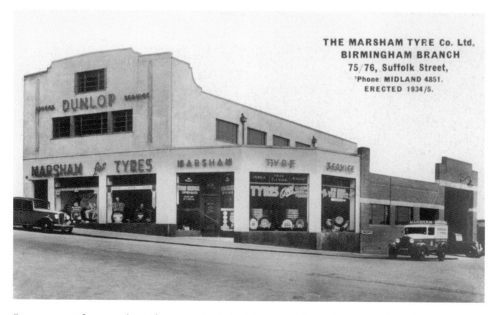

Some twenty-five years later, the motor trade had developed dramatically, both in scale and sophistication. Suffolk Street is also a city centre location. In addition to Dunlop, the names of other tyre manufacturers can be made out. A 'Good' can be seen in the left-hand window, presumably for Goodyear. To the front of the same window a presumed cardboard cut-out of a man kneeling can be seen. He is dressed in a manner reminiscent of a bell-hop from an American film.

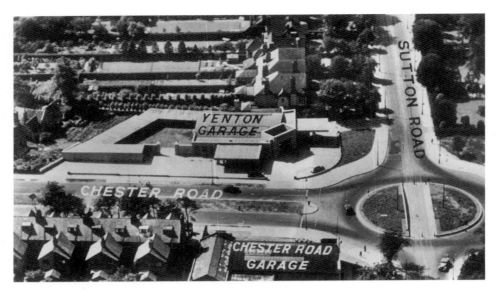

Here we have garages either side of a busy dual carriageway through part of a large northern suburb. Bisecting the traffic island are twin tram tracks on which ran the No. 2 tram service between Steelhouse Lane, city centre, and Erdington. 'Yenton' is held by some local historians to be a corruption of 'Yerdington' another form of Erdington. A display of local patriotism might well be good for business! Traffic islands were just coming into controversial use.

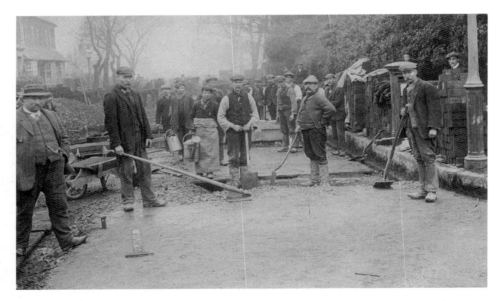

The footsloggers of road transport. Similar cards in what appears to be a private series indicate that this work was carried out in January 1911 on a section of Stratford Road, Birmingham. On this card's back is written 'concreters'. Once again, waistcoats and cloth caps are much in evidence. The stout man, left, wears a more stylish hat and a watch chain – possibly to mark his higher status, perhaps as a supervisor? The long-handled spade/shovel would probably be more at home on the Continent.

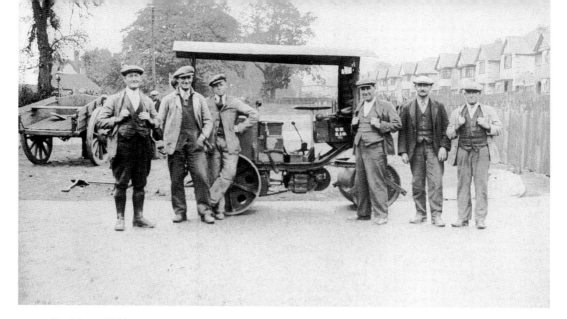

On this card Walter conveys to a 'Mrs Gordon' (address not given) something of his great delight in the completion of the roadworks. The spelling, syntax and limited legibility also convey the impression that Walter had been imbibing strong drink. But some phrases are clear: 'This Road a first Class Road,' or relatively clear: 'By God Not Half of Brum Know Stratford Road Was The Most Lighted ? up Road in England'.

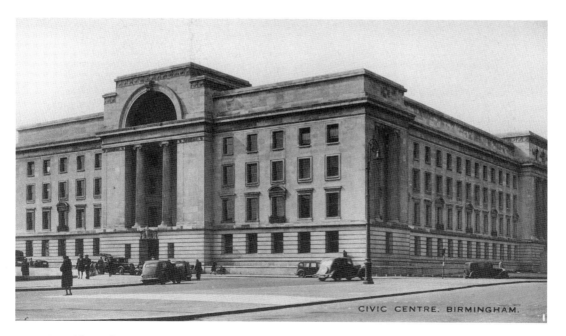

CIVIC CENTRE. BIRMINGHAM.

From blue collar workers to white. After the First World War a 'grand design' was prepared to redevelop an area just west of the Town Hall. This new municipal office block formed part of the planned development. Other new buildings consistent with the above style included the Municipal Bank and Masonic Hall. The outbreak of the Second World War stymied the completion of the 'grand design'.

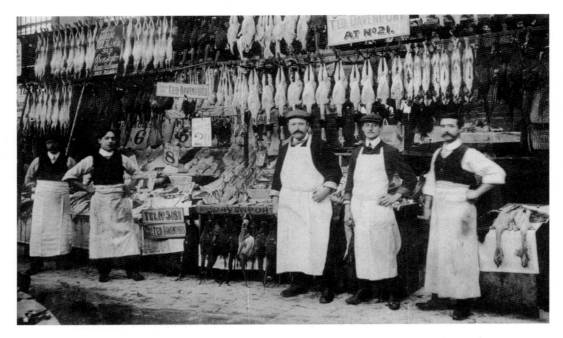

Ted Davenport seems determined that his name should not be overlooked. Given the window, top left, and the sign 'At No. 21' suggests that this fine display of poultry, fish and game was to be admired in Birmingham's historic market hall. The blackboard notice, top left, reads: 'These 22 hares sold to Ben Taylor, Nock's Restaurant, Union Passage.'

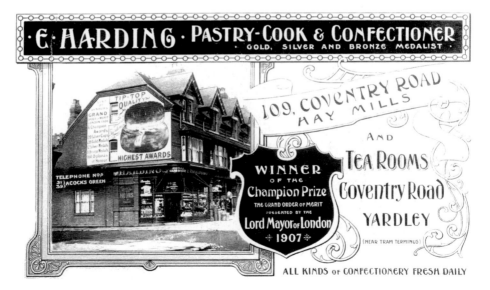

Painter's error? Medalist is the American spelling. To the left of the appetising cottage loaf is a list of awards headed by 'Grand Order of Merit, London 1906'. Above the door can be read 'Royal Steam Bakery'. In addition to the medals, the awards include no fewer than '160 Diplomas of Honour'. Perhaps Mr Harding was American. The Hovis advert is very drab by comparison.

The first Shop opened by the B.C.S. 1881. B.C.S. Jubilee Exhibition 1931

A series of a dozen or so postcards was produced to publicise and commemorate the Golden Jubilee of the Birmingham Co-op, major retailer and employer in the city. An exhibition was held in Bingley Hall to illustrate the range of BCS activities and interests. A replica was built of the Co-op's first shop in Birmingham and attracted great interest. The original Branch No. 1 had been opened in 1881 at 17 Adderley Park Road.

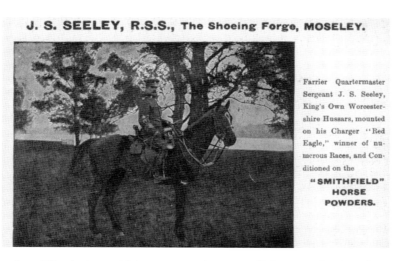

J. S. SEELEY, R.S.S., The Shoeing Forge, MOSELEY.

Farrier Quartermaster Sergeant J. S. Seeley, King's Own Worcestershire Hussars, mounted on his Charger "Red Eagle," winner of numerous Races, and Conditioned on the

"SMITHFIELD" HORSE POWDERS.

A city the size of Birmingham with its very extensive range of job types offered good opportunities for entrepreneurs both large and small. Sergeant Seeley may well have got wind of the idea (late 1890s) to create Birmingham's equivalent to London's Rotten Row in Hyde Park. On the western edge of Canon Hill Park (in Moseley) an avenue was created for horse riding purposes but the project never came to fruition. Even so, this farrier may have prospered, as most carts and wagons of the day were horse drawn.

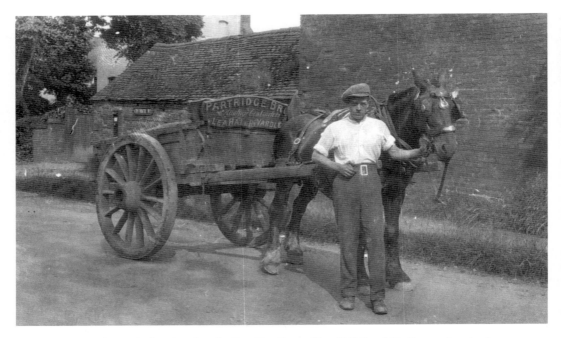

Dated June 1927 this card advertises that the Partridge Bros of Lea Hall Road, Yardley work as haulage contractors. This photograph has been taken in a rural-looking Church Road. What looks like a post box is set into the wall near the road sign.

While not a postcard but an appointment card, this illustration provides some insight into the 'classy' hairdressing of the day. An appointment was kept on 'Sat 29 May'. Research indicates the year to be 1937. As the customer paid ten shillings, she presumably received 'side pieces' treatment. Ten shillings was a tidy sum needing a banknote or the equivalent in coins.

three

Somewhere
to Live

At various times in its history, Birmingham served as an employment magnet attracting would-be workers from all parts of Britain, for example just before and during two world wars. The strain on the housing stock was formidable. Most accommodation available was for rent and the different types of houses are illustrated below. During the First World War no new houses were built. But, empowered by law, Birmingham Corporation made a start on a programme of providing municipal housing. By 1926, 10,000 'council' houses had been built and by the outbreak of the Second World War the figure of 50,000 had been passed. An independent survey carried out in 1936–37 estimated that 38,000 back-to-back houses remained in the city and over 100,000 tunnel-back. But of the 'modern' type, i.e. post-1920, 104,000 had been built.

Previous page: As towns and cities grow and change, a few little corners of rural quiet tend to survive until they appear idyllic or incongruous (dependent on the viewpoint) among new developments appearing on their doorsteps. Postmarked 1919 (?), this card represents such a case: cottages on Witherford Way, off the Bristol Road, Selly Oak.

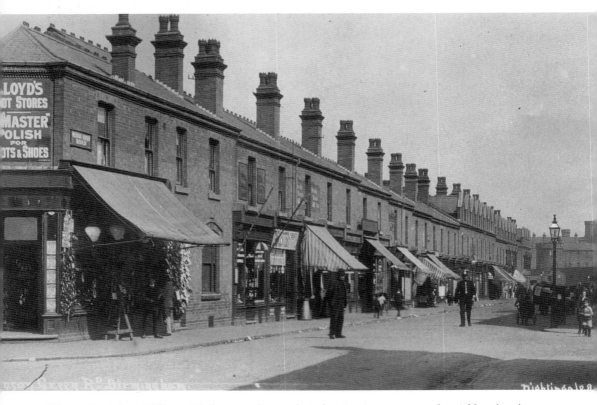

Winson Green Road. What might be termed pretty basic housing in a pretty tough neighbourhood, not least for a policeman. Note the amount of litter. This suburb received mixed benefits from playing host, in the early part of the twentieth century, to 'His Majesty's Prison; City Lunatic Asylum; City Fever Hospital; Infirmary; Workhouse', all on adjoining sites. Job creation, certainly, but at a social price.

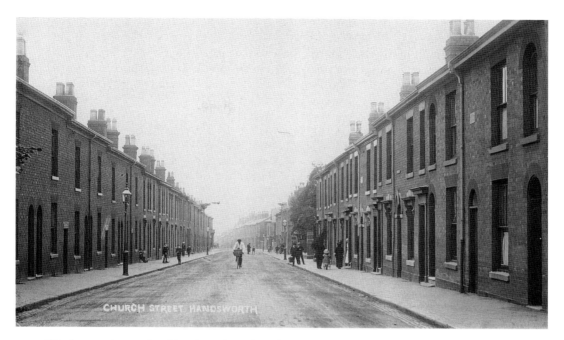

CHURCH STREET HANDSWORTH

This is a good example of housing where front doors open directly on to the pavement. This particular Church Street links Lozells and Nursery Roads. No litter in the gutters in Church Street. If the white-coated errand boy cyclist encounters any traffic at all, it is far more likely to be horses and carts than any motor vehicle. At the end of the terraced houses, right, a tree, in leaf, can be seen. From a 1913 map, this may well be part of the frontage of St Silas's Square which housed a church and church school.

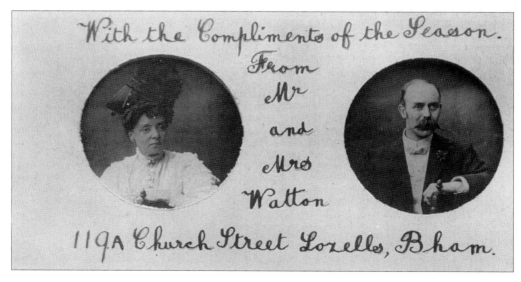

With the Compliments of the Season. From Mr and Mrs Watton 119A Church Street Lozells, Bham.

Drab surroundings do not automatically equate with drab, depressed people. Social aspiration is a hardy, thrusting plant. There is a look of defiance against the odds about Mrs Watton, and that luxuriant moustache of her husband was doubtless a source of great pride for both of them as, no doubt, was the highly personalised Christmas card.

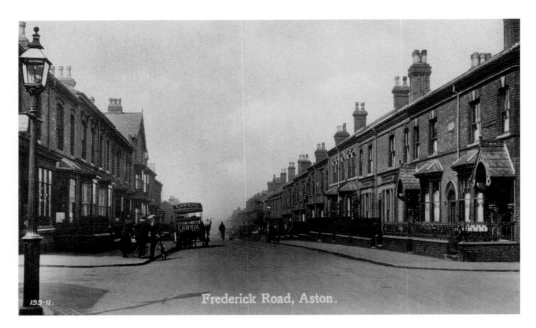

Frederick Road, Aston.

Only a short distance from Aston Park, the houses in this road are typical of many in the older residential parts of the city. These homes boast a token front garden, itself bounded by a low brick wall surmounted by low iron railings. Bay windows are fairly standard, giving more space internally and relieving the flat monotony of frontages common in terraced houses. The small writing on the CAMWAL cart appears to be 'Fruit Syrups and Cordials', suggestive of a slightly better-off group of customers.

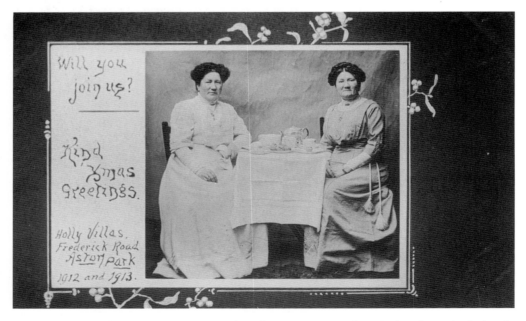

Did anyone accept the invitation? Two matronly widows? Have a care chaps, look at the coyly displayed mistletoe.

Another rung up the social ladder. Similar type houses to those shown on the previous page but mature trees now line both sides of the road. Postmarked 1925.

On the back of this card is scribbled: 'Alderman Wood and family in the gardens of Pinewoods, Mostyn Road, Handsworth.' In colloquial terms, an alderman was a bigwig local government politician. In the mid-1940s Birmingham City Council consisted of 102 councillors (three from each of thirty-four wards) and thirty-four aldermen. The councillors, elected for three years, elected the aldermen, for six years. This system was replaced in the post-war period by all councillor elections.

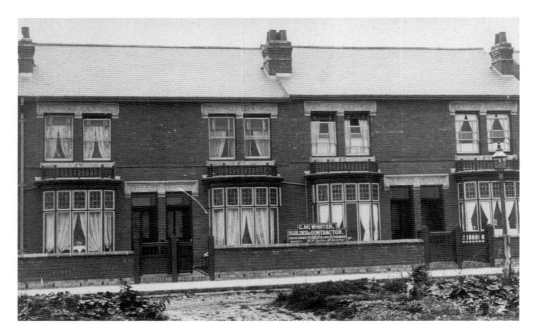

These houses are thought to have been built about 1910. When the photograph was taken, C. McWhirter was inviting, via the noticeboard, anyone interested in buying the houses 'in lots to suit Purchasers' to apply to his given Ward End address. Lace curtains of every configuration were the norm, as were sash windows shown here in the bedrooms. Those windows also appear to be fitted with horizontal blinds conceivably to save occupiers the cost of new, heavier curtains to ensure night-time privacy.

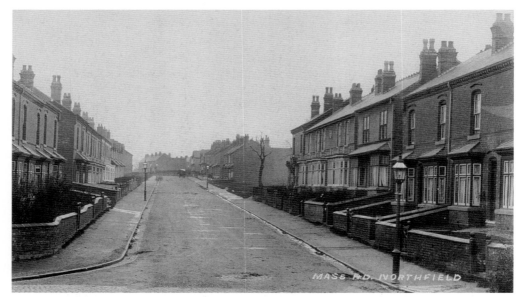

Many similarities existed between houses in south and north Birmingham. But within a single road different types of houses could be found, as here, close to the centre of Northfield 'village'. By the solitary tree there appears to be another plot of land awaiting development. (Postmarked c. 191?)

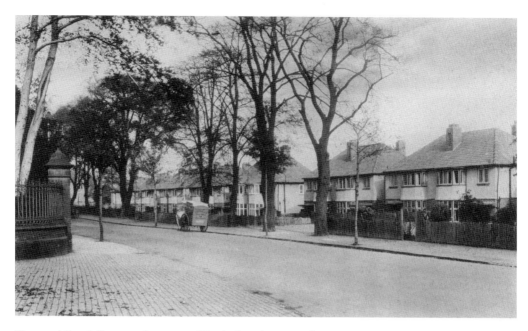

Hamstead Road. Between the wars, as Birmingham began to claw its way out of economic depression, where fields had once been, especially in the then outer suburbs, modern semi-detached houses mushroomed into being during the 1930s. This card illustrates one example of that process. The pair of neat semis on the right of the card stand directly opposite one of the main entrances to Handsworth Park.

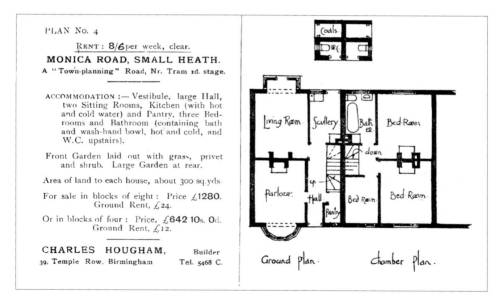

PLAN No. 4

RENT: 8/6 per week, clear.

MONICA ROAD, SMALL HEATH.
A "Town-planning" Road, Nr. Tram 1d. stage.

ACCOMMODATION :— Vestibule, large Hall, two Sitting Rooms, Kitchen (with hot and cold water) and Pantry, three Bedrooms and Bathroom (containing bath and wash-hand bowl, hot and cold, and W.C. upstairs).

Front Garden laid out with grass, privet and shrub. Large Garden at rear.

Area of land to each house, about 300 sq. yds.

For sale in blocks of eight: Price £1280. Ground Rent, £24.

Or in blocks of four: Price, £642 10s. 0d. Ground Rent, £12.

CHARLES HOUGHAM, Builder
39, Temple Row, Birmingham Tel. 5468 C.

Ground plan. chamber plan.

The front of the card shows not semis but a modern terrace block of eight houses. From the above design, would-be customers are obviously looking for facilities not available to earlier generations. The builder must believe that potential customers are better off than they used to be. But when does a kitchen become a scullery or vice versa? Text and drawing don't quite match!

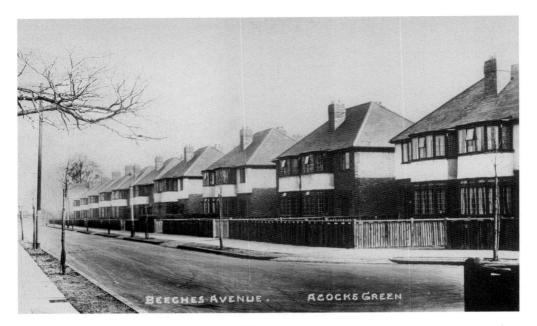

BEECHES AVENUE. ACOCKS GREEN

The card bears a message written on 23 June 1937. More new semis, rather uniform in appearance. The bay window design has been extended to the front bedroom which also has a small opening window, top centre. Newly planted trees and sloping access from road to pavement suggests a certain amount of planning for the future has taken place.

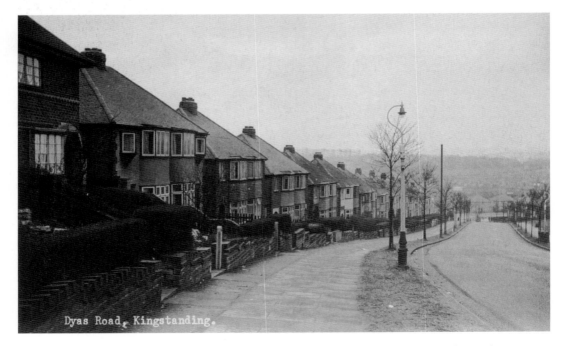

Dyas Road, Kingstanding.

For reasons already touched on, thousands of people were found rented homes in Kingstanding and other council house estates. Newly planted saplings again feature.

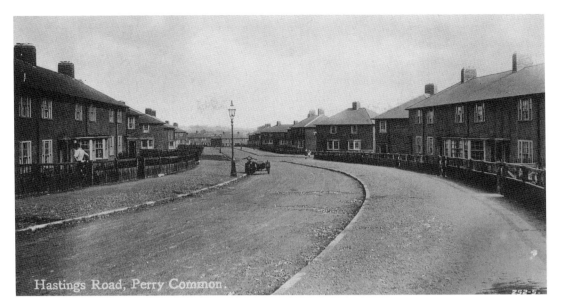

As new developments go, this must be one of the least inspiring, prompting jibes about barracks. Conceivably such basic designs assisted the speed of construction, keeping down costs and, hopefully, rents as well.

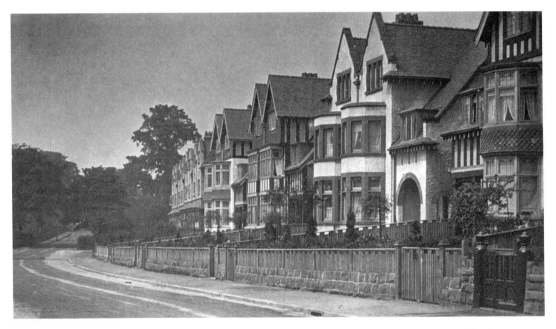

Kingsbury Road, Erdington. Semi-detached houses were by no means a new concept. Older houses, especially those built before the First World War, often made provision for a serving maid to live-in. Many girls during those years were employed 'in service'. Some semis were quite grand, of three or even four storeys where cellars had been built. As shown, within a few yards quite different designs can be identified, making the section of road far more interesting in appearance.

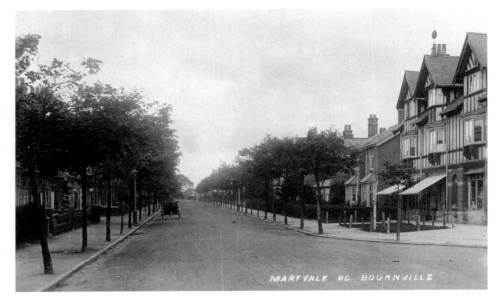

In the 'factory in a garden' suburb of Bournville, 'living over the shop' displayed a certain elegance.

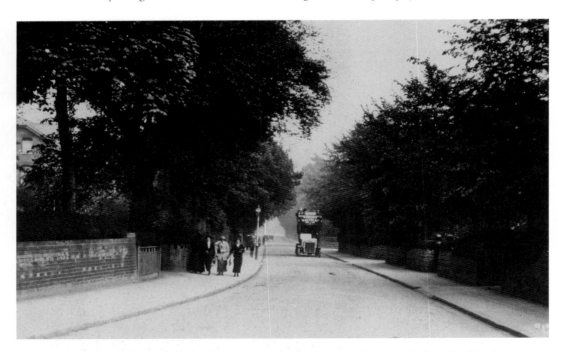

Wake Green Road, Moseley. The finest and grandest houses were largely to be found in Moseley and Edgbaston, houses for those who 'had made a bob or two' in business or the professions (but not professional footballers at this time!). Many houses were screened from the public gaze, as shown above (the card is postmarked 1919). The decision to allow a horseless carriage, a motor bus no less, to provide a service along this august road, had probably been highly controversial. The open-top bus carries an advert which appears to read 'Winters Malt Wheat Bread'.

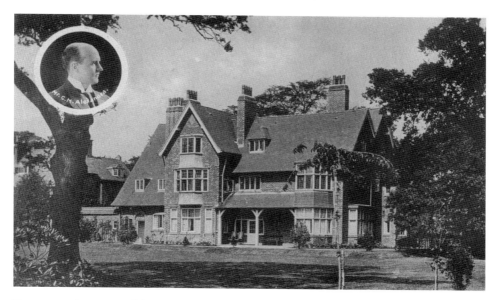

By contrast, the owner of this mansion in Kings Heath, very modern for its day, seems anxious to publicise his home, the card having been produced by a notable firm. Research might show this Mr Alexander to be a descendant of one Archibald Alexander (1772-1851), an American Presbyterian preacher whose two sons became noted preachers. The design of 'Tennessee' would seem to be years ahead of its time, for the message and stamp on the card's back are dated 19 December 1906.

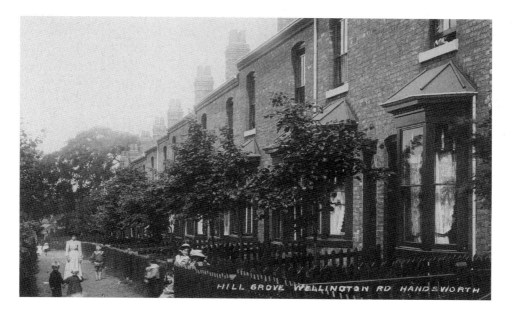

Tucked away in odd corners, usually at some distance from busy thoroughfares, unmade roads could be found, sometimes cul-de-sacs, sometimes three sided, rather like a staple, with houses on each side. Just a few yards from Hill Grove the Outer Circle bus service (No. 11) made its way along Wellington Road. Similar 'groves' could be found nearby in Crompton and Stamford Roads.

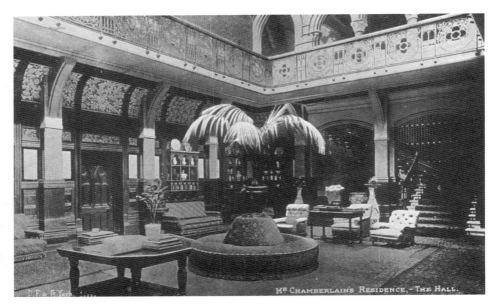

Very few Brummies could aspire to the grandeur and opulence of 'Highbury's' interior, 'Highbury' being the home of Joseph Chamberlain in Edgbaston. But 'Radical Joe' had done well out of his association with GKN (screw manufacturers). He retired early and, as councillor, mayor and MP, had done much to improve the living conditions of Birmingham people (see pp 122, 123, 124). Few Brummies of the time would have begrudged him his family home creature comforts.

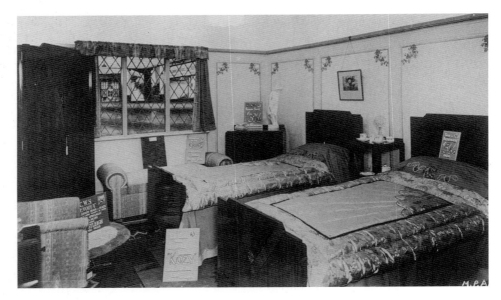

At this exhibition/celebration in Bingley Hall, Birmingham Co-op not only did its best to recall past achievements but to raise consumer expectations and attract customers. Somewhat surprisingly and rather saucily for 1931, a figurine of a nude lady, shielding her eyes with one arm, stands on the dresser in the far corner, and next to a card bearing a price tag, £32 10s 0d, for a bedroom suite, 'Kozy'.

four

Suburban
Shopping

Napoleon's scornful dismissal of Britain as simply being 'a nation of shopkeepers' did him no favours and, judging by conditions a century later, the stubborn British had deflected not one jot from their pursuit of shopkeeping and the practice of shopping itself. Even by 1945, most people found it handy to do the bulk of their everyday shopping within reasonable walking distance of home. They might hop on a bus or tram to travel into town or to their local high street, to order furniture, pay the gas bill, or buy Bing Crosby's latest hit record. But running short of sugar, or needing an extra loaf, it would be a case of, 'just slip to Wrensons, there's a good lad'. And besides, the many corner shops served a secondary, if unstated, purpose as local news and views and gossip exchanges, enhancing the local neighbourhood spirit. That certainly helped in air raids and the street parties that followed victories.

Previous page: Typical of the one man and a boy greengrocers in a back street, the address of this shop is not known. Worth noting are the scales and heavy weights – and the boy. He could be wearing a tie simply because he had been told he was 'going to have his picture took'. His snake buckle belt was standard schoolboy wear for the late 1920s, early 1930s – as the author knows from personal experience.

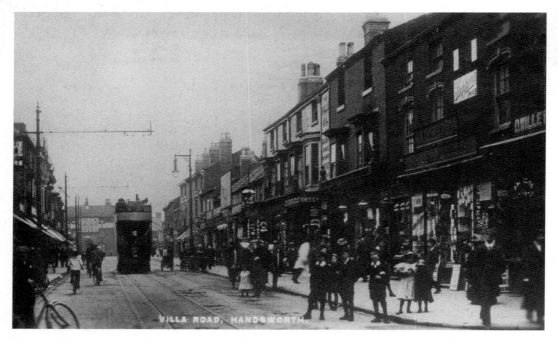

VILLA ROAD, HANDSWORTH.

Above: Villa Cross was crowded chock-a-block with shops, very busy on a Saturday, silent and still on a Sunday. Most churches, chapels and Sunday schools were well attended on the Sabbath – a term in use in the days of open-top trams, as here. Behind the tram stands the Villa Cross Hotel. In 1915 the Villa Cross Picture House opened.

Opposite below: Lozells Road leading off right from Villa Cross to reach Six Ways, Aston contained groups of shops at intervals along its length. Lozells Road was well served by trams, the No. 5 service going its full distance while the No. 24 service, also starting in Villa Road, travelled as far as Wheeler Street before making for town. Woolworths opened a branch on Lozells and this shop with its policy of 'nothing over sixpence' became very popular.

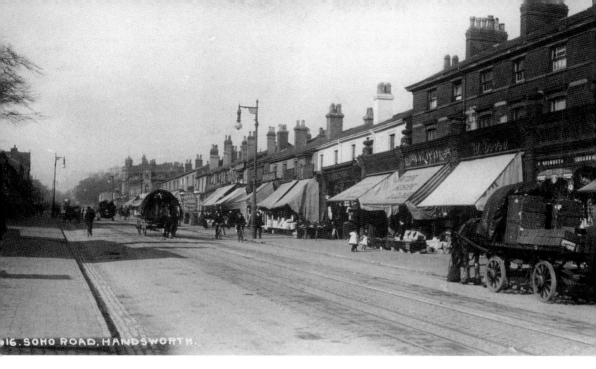

Above: Soho Road constituted an important section of the roads linking the city centre and the Black Country. As tramlines can be seen, but no overhead wiring, the photograph must be from the period of the cable car, introduced in 1886/7, extended on this route to the New Inns, Handsworth in 1889 and remaining in use until 1911, when the electric tram took over. The nearest carthorse seems well occupied with the contents of his nosebag.

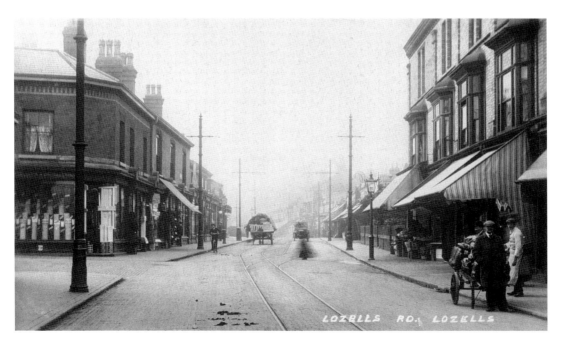

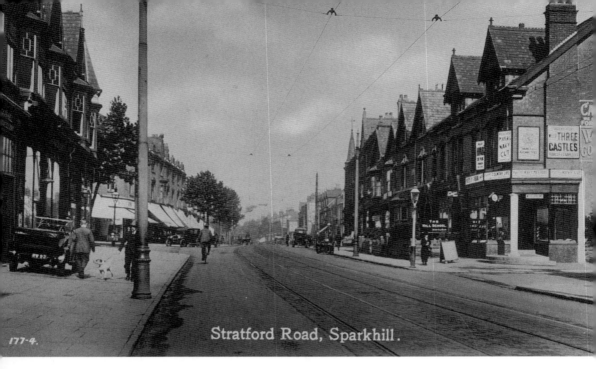

Stratford Road, Sparkhill.

Above: Stratford Road, Sparkhill. As tram and bus routes steadily extended, like growing spokes from a city centre hub, greater opportunities became available to the woman, sometimes the man, with the shopping bag. Arterial roads, for example those leading towards Stratford, Warwick and Dudley, would pass through shopping areas that had once formed the centres of erstwhile village-like communities. Some retained the term 'High Street' as in Kings Heath, Stirchley and Erdington. Here there is a pavement broad enough to 'allow' double parking!

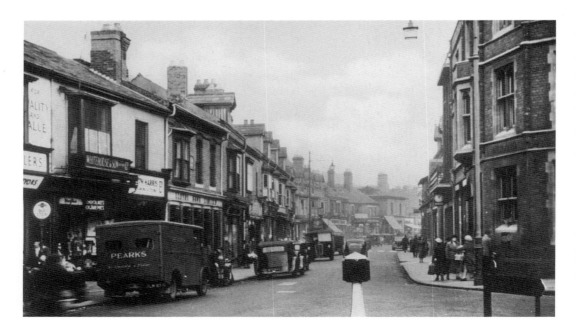

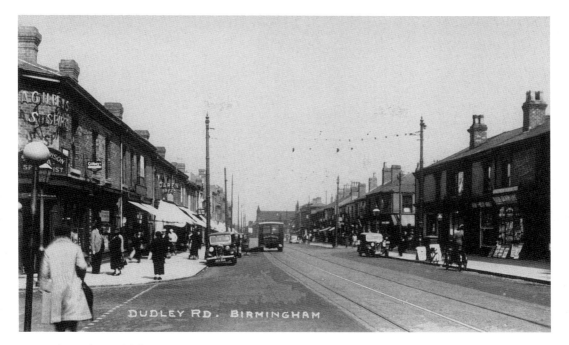

Above: The road left is Winson Green Road leading past the prison. Behind the car, right, is the entrance to Icknield Street. Out of sight, but close by, is the Dudley Road frontage of Summerfield Park.

Below: Postmarked 7 September 1909. Two trams can be made out in the distance.

Opposite below: Warwick Road, Acocks Green. Pearks had a chain of grocery shops. Lloyds Bank and the Midland Bank face one another across the road.

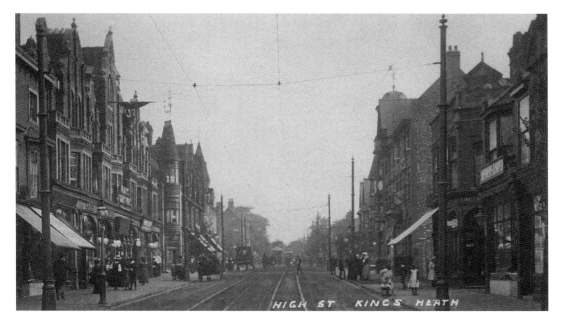

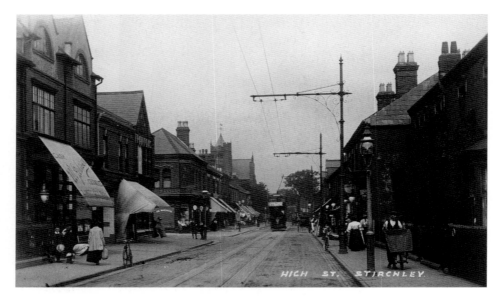

Postmarked 13 August 1912. The open-top tram is close to Mary Vale Road and so not far from Cadburys Bournville works. The corner shop, where signs can be seen, appears to be the business of one 'D. Jones' concerned with ' Flannels Linens' and 'The Warehouse'. On the nearest shop blind the writing seems to denote: 'Cash Chemist Lowest City Prices W. Johnson'. The man with the wheelbarrow is wearing a waistcoat, very much the practice as seen on other cards.

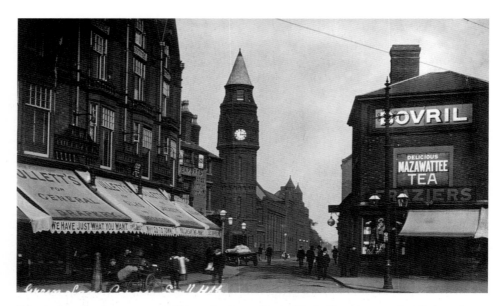

Price is also of major concern to Ulletts, the shop with the blinds. The fringe on the blinds reads: 'We have just what you want : Why go t' town: You can save time and money: See our... ?' On the blinds, Ulletts make plain that they stock 'General Drapery, Silks' and what looks like 'Jackets'. On the next building can be read 'Davenports Noted Bottle Stout'. This brewery specialised in delivering beer and stout to people's homes. The 'corner' is thought to be the one with Coventry Road.

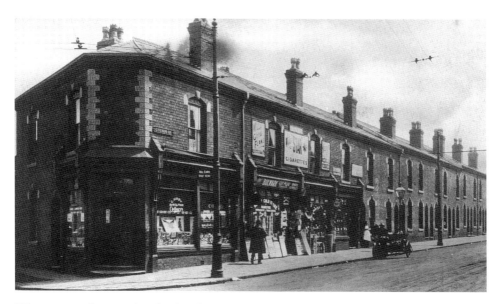

Whoever gave the name 'Cuckoo' to this road must have had a wry, even cynical sense of humour. Not far from Nechells gas works few roads in Birmingham would have been less likely than this one to hear the cuckoo's call. This road provides another example of front doors opening directly onto the pavement. 'All cars stop here' states the sign on the post (meaning, of course, tramcars). Maybe 'C. Kirby' at the corner shop was helped in his business by the sign's location.

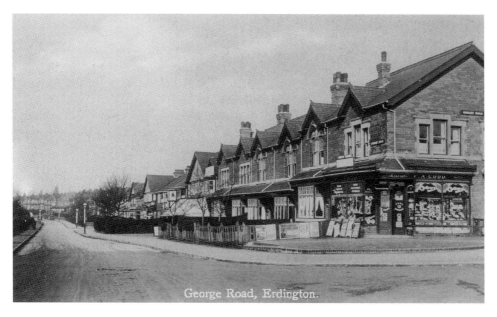

A corner shop in a suburb with a much better chance of hearing the cuckoo, George Road skirting Brookvale Park. The road sign, though blurred, contains six letters and so could be Rosary Road. The proprietor's name appears to be 'A. Codd', selling among other things minerals and Fry's chocolate.

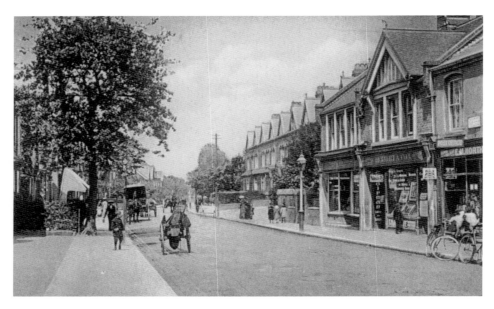

From the use of 'village', the boy in knickerbockers and the dress style of the ladies, this is almost certainly a pre-First World War scene. Herbert A. Cox appears to be the shop's proprietor. The vertical advertisement apparently reads 'Chairman cigarettes and tobacco'. 'Chairman' was a brand of cigarettes manufactured by R.J. Lea Ltd of Manchester and Stockport. The right-hand shop also serves as a post office.

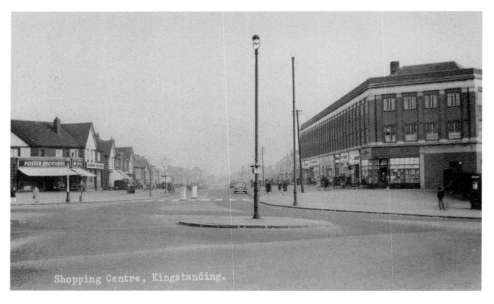

By contrast, these shops built some twenty-odd years later for the new council house estate seem stark and far less appealing. But they are spanking new and so, up-to-date. 'Foster Brothers', left, was a multi-branch men's tailors. The card states: 'looking down Hawthorn Road' a busy road linking Kingstanding and College Roads in a large area of 1930s housing development.

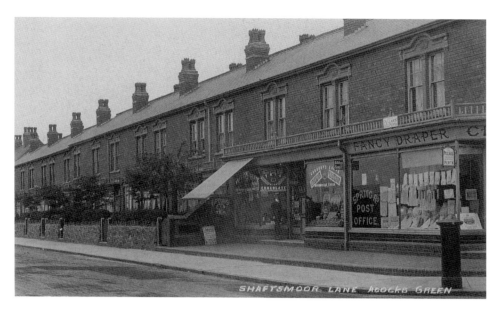

The bright red pillar boxes were often sited, as here, on a convenient corner. The self-styled 'Fancy Draper' displays some fancy (ladies) undergarments – including bodices? This shopkeeper is also an agent for Pullars of Perth, cleaners and dyers. In the shop next door, a number of well-known brands can be identified including Frys and Liptons. Also advertised are 'Whites Mineral Waters, Ginger Beer, Soda Water, American Cream Soda' and what looks like 'Kaola'. NB Spring Road (see post office) runs into Shaftmoor Lane.

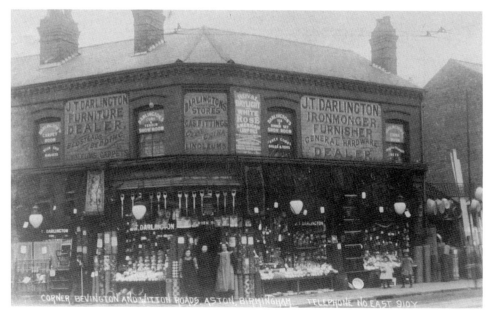

An Aladdin's Cave corner shop ironmongers in the heart of highly industrialised Aston. The upper rooms are used for display purposes – from fenders to fancy goods, including dolls and toys. Stocktaking must have been great 'fun'!

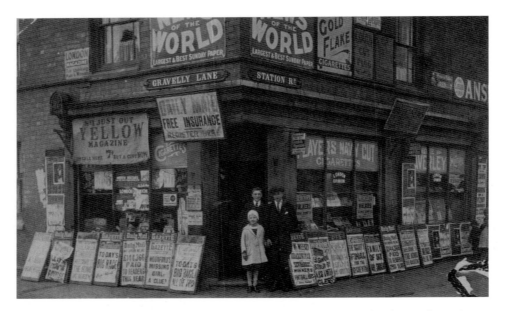

One newsagent's support for the notion: 'If you've got it – Flaunt it!' An abundance of news in this case. Several of the placards are concerned with one of the major horse races of the season, cf *Daily Express* 'The Scout's Final for the Cesarewitch'. This fount of information was to be found on the northern edge of Erdington 'village'.

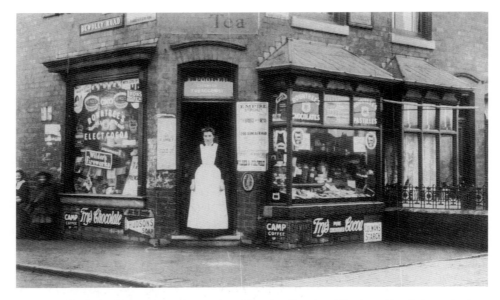

E. Pooler, licensed tobacconist on the corner of Bewdley Road and Pershore Road, shows, in the side window, the famous Black Cat advert of Carreras cigarettes. Two of the three major cocoa and chocolate firms are well-represented in advertising terms but nothing for Cadburys, which is just a short walk away. Bonfire night must have been near when this photograph was taken, a 'Wilder's Fireworks' advert appearing in the left window. It would be interesting to know what was showing at the Stirchley 'Empire' (cinema) but the lettering is too indistinct.

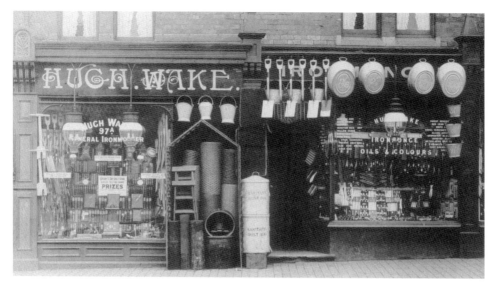

Ironmongers' wares lend themselves to displays of particular interest to men. But Mr Wake's stock includes items to catch a lady's eye, e.g. the wooden washing-dollies★ left, the cutlery right and the four tin baths. The PRIZES notice carries this wording: 'Severn St, Day Adult School Class, 14 Selly Oak Branch...' The shop's address is 99 High Street, Bournbrook. (★ Known as 'possers' in some parts of the country.)

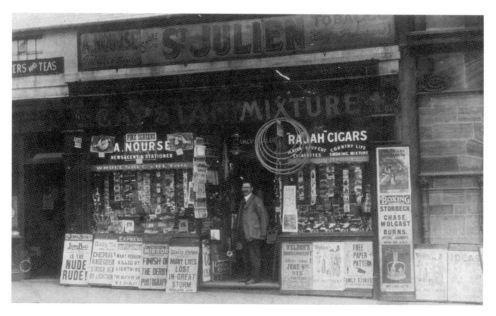

Another newspaper-tobacconists, this time in High Street, Aston. Attention-grabbing placards include: nudity; the result of the Derby horse race; fatalities resulting from lightning and storm. The centre placard adds: 'The death of Sir W.S. Gilbert'. The brilliant librettist and parodist of Gilbert and Sullivan light opera fame died on 29 May 1911 in tragic circumstances. Mr Nourse has fine displays of postcards for sale in both windows.

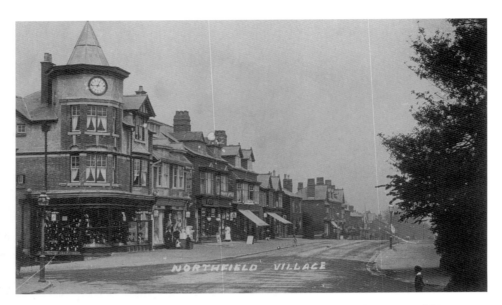

Here is another example of the village high street type of shopping. On the corner of this crossroads on Bristol Road (Bell Hill left, Church Road right) stands 'Huins Bootmaker and Repairer since...' The term 'Huins Corner' passed into common usage. *Country Life* is on sale a few doors down. Postmarked 1912.

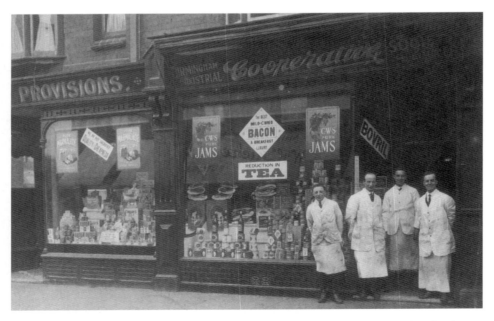

As probably the largest grocery business in the city, let the Co-op have the last word on local shopping. Co-op grocery shops often formed one unit of a two- or three-shop branch, a butchers and/or a greengrocers often forming part of a branch. Branch No. 1 in Adderley Park Road opened in 1881. Branch 100 opened its doors in 1929 at Acocks Green. The shop above was located in Ladypool Road, Sparkbrook.

City Centre - Sights and Shops

True to its motto of 'Forward', Birmingham was the first city in the country (following enabling legislation) to propose a town planning scheme. In short, many of Birmingham's principal civic buildings had been completed well before official planners had become a force in the land. And so the Council House, the Town Hall, both cathedrals, Anglican and Roman Catholic, the main post office, the law courts, all reflect quite different styles (see below). They appear to be acknowledging debts to what was worthy in the past rather than controversially projecting the 'future'. As for shopping, Birmingham city centre, being relatively compact, had most of its top-range shops, departmental stores and specialist shops conveniently close to one another and to tram and bus services.

Previous page: Lewis's, especially in the 1930s, stood out as Birmingham's most popular departmental store, favourably situated on the corner of Bull Street and Corporation Street. In 1937, Lewis's claimed that it was 'really 200 shops in one', selling not only a vast range of goods, but services as well: hairdressing, travel bureau facilities, banking and catering arrangements.

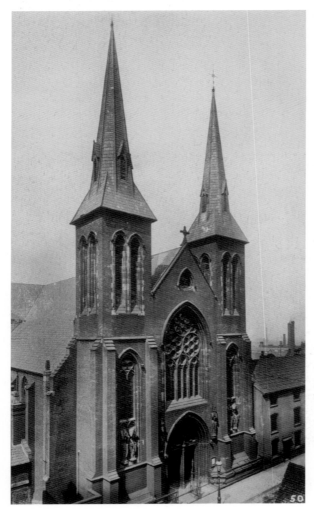

Dating back to 1839 and built of red brick in what has been termed Baltic German style, this cathedral contains a sixteenth-century pulpit. St Chad's was the first Roman Catholic cathedral to be built in England since the Reformation.

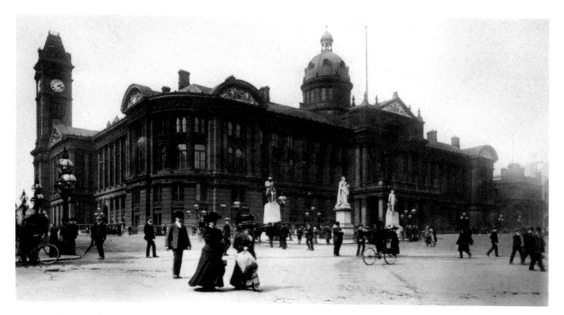

This seat of government for Britain's second city, built during the 1870s in Renaissance style, touched the lives of 1,055,000 citizens in 1939. The Council had become responsible for gas, electricity and water supplies, bus and tram services, parks and libraries… the list of responsibilities was a long one. Birmingham Corporation was, in fact, a major employer, some 42,000 people being on its payroll by the end of the Second World War.

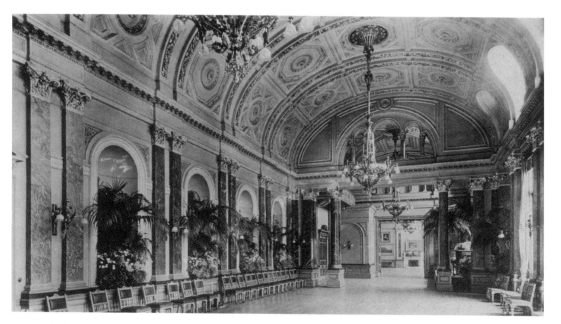

This handsome room, one of three for receptions, was reached by a fine, imposing staircase set under the building's dome. The room, ornate for some, may rightly be considered as redolent of Victorian self-confidence and civic pride.

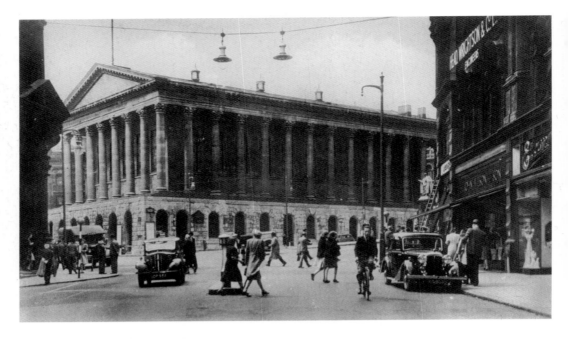

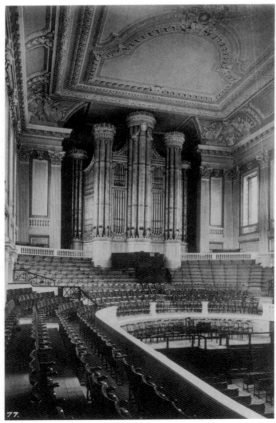

Above: For the emergent 'workshop of the world' it was decided that Birmingham's Town Hall should resemble a temple of ancient Rome. Built in brick and clad in marble, it opened to the public in 1834. Most people who passed through its doors were listeners, interested in music, speeches and even fiery oratory. In 1901 a future British prime minister, Lloyd-George, had to be smuggled out of the hall disguised as an unusually short policeman, having upset some stroppy members of his audience.

Left: An official view point, *c.* 1945: '...the fine organ in its reconstructed form is greater now than when Mendelssohn himself played upon it in 1840...'.

By the end of 1945, this stately and sturdy building had served as the city's head Post Office (in Victoria Square) for fifty-five years. It is interesting, if fruitless, to speculate how many postcards of Birmingham scenes started their journeys here. It is on record that between 1842 and 1914 some 600-plus photographic studios opened in Birmingham. NB every man jack of the passengers descending the open staircase of the bus is wearing a hat.

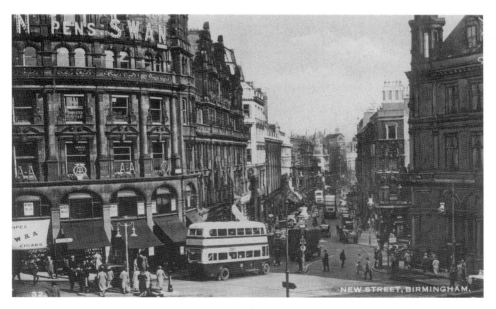

A corner of the same post office can be seen here, right, at the top of Pinfold Street. Across the road is the rounded corner of what became known as Galloway's Corner, Galloway's being a 'dispensing chemists' also selling cameras and films. Obviously, serious shopping was carried out in New Street where motor traffic was heavy.

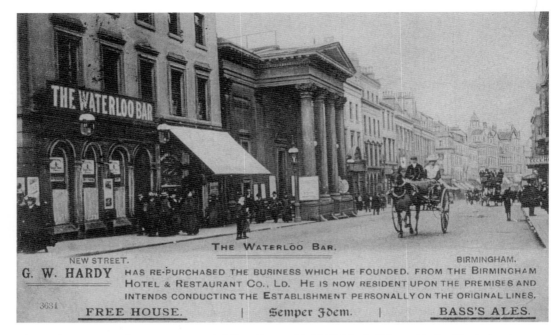

THE WATERLOO BAR.

NEW STREET. BIRMINGHAM.

G. W. HARDY HAS RE-PURCHASED THE BUSINESS WHICH HE FOUNDED, FROM THE BIRMINGHAM HOTEL & RESTAURANT CO., LD. HE IS NOW RESIDENT UPON THE PREMISES AND INTENDS CONDUCTING THE ESTABLISHMENT PERSONALLY ON THE ORIGINAL LINES.

3634

FREE HOUSE. | Semper Idem. | BASS'S ALES.

This card was written from a quieter period, 'Sat. 21st Jan 05. 8PM'. The building with the Classical-style columns housed the Gallery of the Royal Birmingham Society of Artists. It was demolished in 1912. *Semper Idem* – Mr Hardy? Always the same?

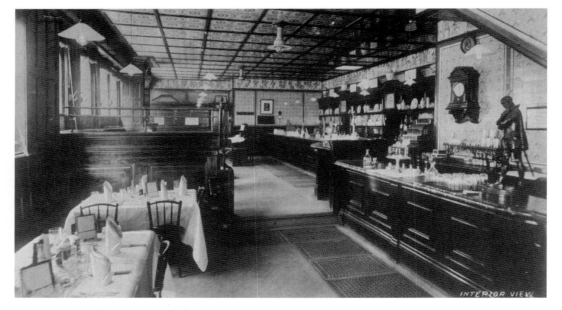

INTERIOR VIEW

With its elegant solid wood fittings, spotless tablecloths and snowy napery, Mr Hardy seems determined to attract a 'better class' of customer, businessmen most likely and affluent young bucks. Billiards could be played on the first floor where 'public and private rooms' were available. (Details on a companion card.) Who is the hero on the bar counter clad in some armour and wearing a cape and a feather in his bonnet?

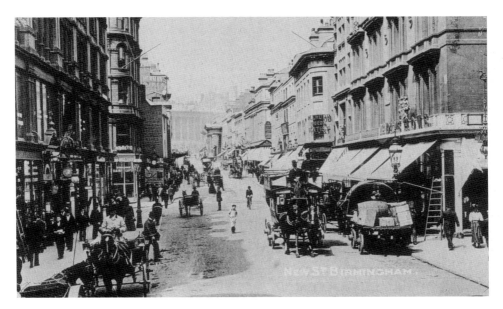

A view postmarked 1904 from the lower end of New Street looking towards the Town Hall in the days when horse power really prevailed. A variety of horse-drawn vehicles can be identified, including possibly three horse buses. The wagon right may be delivering casks and crates freshly loaded from nearby New Street Station. The carriage, front left, is in the care of a uniformed coachman sporting a long whip. At Whitsun, a very popular horse fair was held near the Bull Ring.

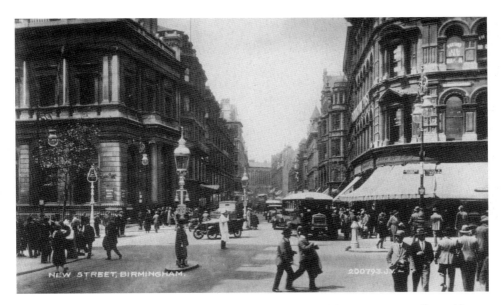

Clear evidence both that motor vehicles have replaced horses and that New Street still provides plenty of shopping opportunities. The car turning by the traffic cop is about to enter Stephenson Place, by the station, signposted on the traffic island, right, as are 'Walsall 9 and Lichfield 15¼ A455' along Corporation Street. The solid, stolid Midland Bank stands guard over the 'spending a penny' facilities close by the railings.

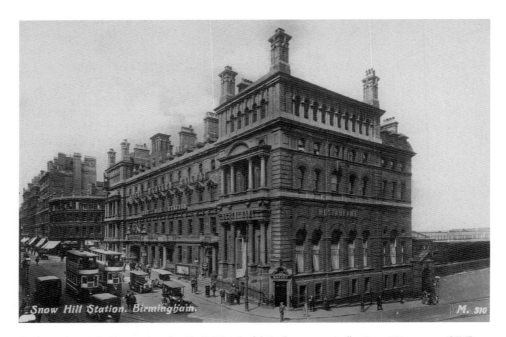

An imposing main line station for God's Wonderful Railway, prosaically, Great Western or GWR. Snow Hill station opened in 1852. Being built on a narrow site, when the station was made larger, platforms became unusually long. The station gave 125 years of service.

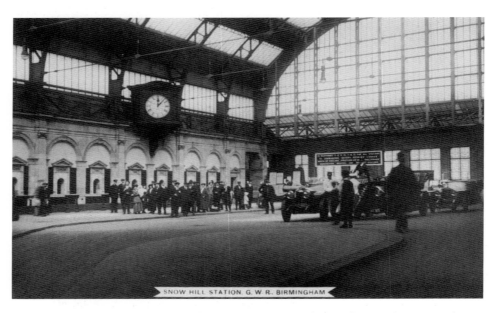

'Meet you under the clock at Snow Hill station at...' – a popular spot for a rendezvous. 'In the main booking hall the pillars and ticket office windows were faced in white Carrara ware, and the whole of the entrance concourse was covered by an arched roof with a single span of 93ft 9½ins, the centre of which was 54ft from the ground.' (Derek Harrison.)

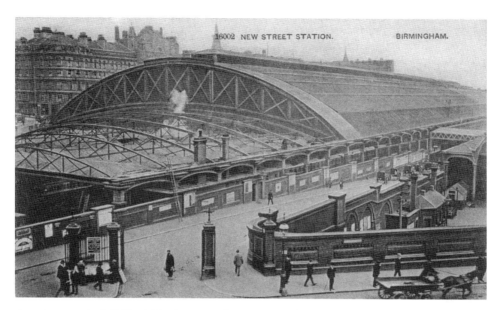

A card postmarked 1905 which gives a good impression of the size of the other main line station in Birmingham's city centre. The station took seven years to build, being opened in 1854. Later its size was doubled by taking in Queens Drive. When built, it was held to be the largest single-span roof in the world.

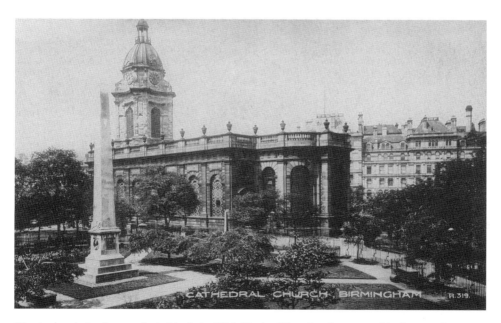

Birmingham's Anglican cathedral built in 1715. During Victorian days, a notable feature of its interior became the design of its stained-glass windows, the artist being the Birmingham-born Burne-Jones. The paths that criss-cross the surrounding land were useful for many pedestrians walking between the city's central stations, for employees working in nearby banks, insurance and commercial offices – and, of course, for city shoppers.

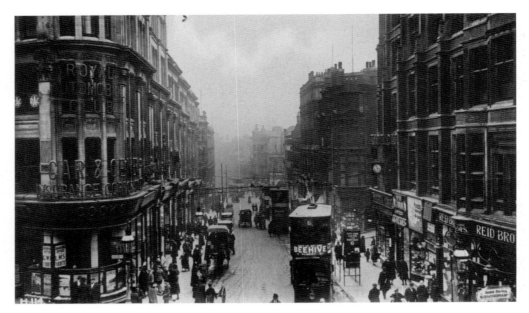

This view, taken from Corporation Street, typifies the bustling nature of a number of the city centre's side streets. This one provided the termini of several tram services. The No. 6 tram in the foreground is just about to start its journey. The sign to its right reads: 'Cars load here for Perry Barr 6'. The 'Beehive' was a popular, relatively low-price store. The RAC and Cooks Travel Agency have offices left, while across the road Reid Bros attract customers seeking high-grade tailoring.

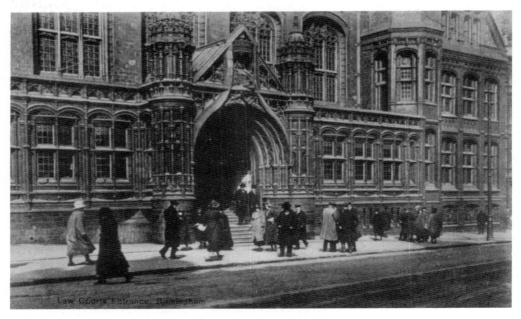

Known as the Victoria Law Courts, this fine building in Corporation Street with its dignified, magisterial air dates back to 1887-91, Queen Victoria herself having earlier laid the foundation stone. The courts have never been short of work since!

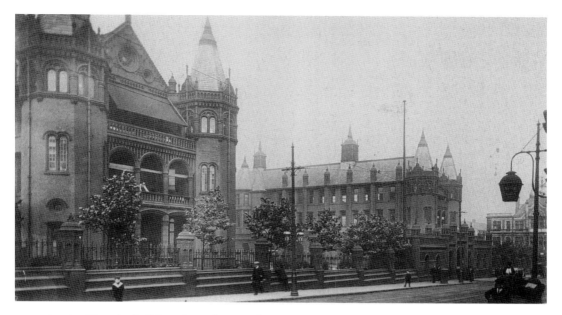

Another Victorian building, General Hospital in Steelhouse Lane accepted its first patients into its care in 1897. A hospital, at that time, of some 350 beds and until the building of the Queen Elizabeth in the 1930s, it was regarded as the city's flagship hospital. Another striking redbrick building all too soon soot-begrimed by Birmingham's many smoke stacks and myriads of domestic coal fires.

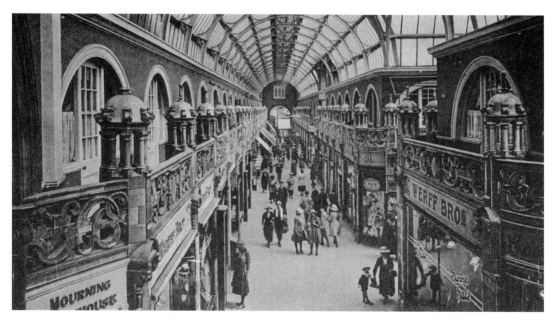

City Arcade. This arcade, like others, was built to make the best possible use of potential shopping sites. They enjoyed the added advantages of being traffic-free, allowing safe and dry walkways between busy streets and taking shelter from the rain on occasion. Arcades often had some high-class shops but the one bottom left strikes a rather jarring note.

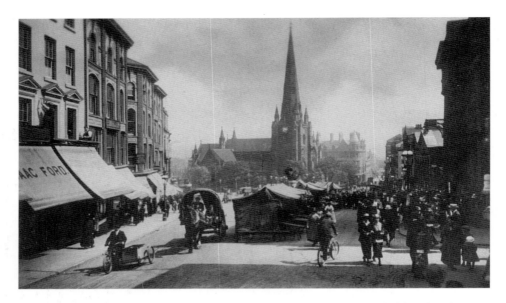

A general view of Birmingham's much-beloved Bull Ring. The authority to hold markets here had existed for more than 800 years. The massive market hall dating back to 1835 and designed to house 600 stalls was knocked out of action in August 1940 in an air raid that totally burned out its interior. The hub-bub of street traders and their customers, patent medicine sellers, preachers and political orators combined to make shopping entertaining as well as a matter of commerce. In the background stands the historic St Martin's church.

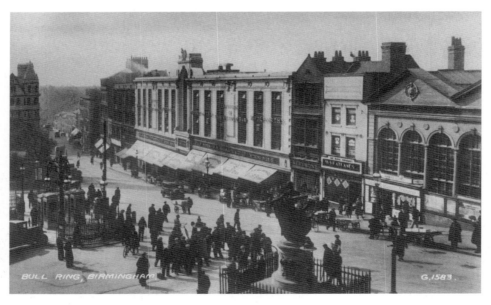

A view nearer to the church, with Nelson's statue now facing a new sort of invasion, that by more modern shops, including Woolworths. Unveiled in 1809 this statue is thought to be the first ever to honour Britain's greatest sailor.

six

Religion,
Education,
Health,
Transport

Birmingham was tolerant of the many different forms of Christian worship and of other faiths. Local churches and chapels exercised a powerful influence on the communities they served, not least in relation to social welfare matters including work with children in Sunday schools. A more co-ordinated and comprehensive form of education rapidly developed from 1902 when local authorities took general responsibilities for children's education. Classes could be large, forty to fifty in a class was not uncommon. Discipline was strict and use of the cane was quite widespread. But overall, standards of achievement steadily rose. By the end of the Second World War, the Education Committee was in charge of some 400 schools as well as a number of technical schools and colleges. While health standards and services improved, progress was piecemeal in nature. The age of the welfare state had yet to dawn. As for transport, tram and bus services were owned and controlled by the Corporation but plenty of scope remained for private enterprise to undertake commercial transport ventures, on road and on rail.

Previous page: This large Aston parish church with its lofty spire had its beginnings in medieval times, being modified and restored over the years. The hoarding outside the church informs parishioners and the world at large of a 'Pan Anglican Congress' at the 'Town Hall' involving the 'Archbishop of Melbourne'.

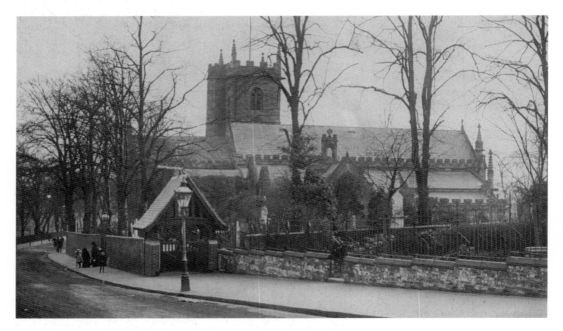

Above: The large parishes of Aston and Handsworth did not formally become, by incorporation, part of Birmingham until 1911. St Mary's church, Handsworth dates back to the twelfth century and in its later history had strong associations with Boulton, Watt and Murdoch. All three men, pioneers of industrialisation, are buried in the vaults of the church.

Opposite below: Located in Friary Road, Handsworth Wood, and set in spacious grounds of 23 acres, this Wesleyan Theological College opened in 1881. On a related postcard a student has written: 'The college is a fine place. I have a study & bedroom to myself. There are 68 of us in residence. The 5 hours from 9a.m. to 2 p.m. are occupied in attending lectures given by the tutors; the afternoon is spent in recreation – from 2:45 to 5:15 & the evening study.' The photograph shows students and tutors in 1911-12.

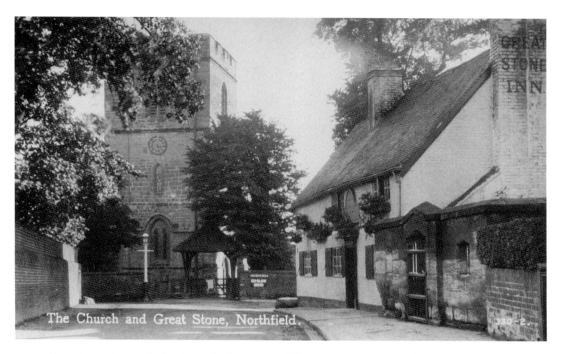

The Church and Great Stone, Northfield.

Above: A parish church also dating back to the twelfth century and enlarged from time to time. A new organ was installed in the church in 1937 gifted by Lord Austin, of Austin Motors fame, and his wife. Dating back to the nineteenth century a church school was established. The Great Stone Inn features on many postcards and has a long history including the keeping of a pound for stray animals when Northfield was basically a rural area – also absorbed into Birmingham in 1911.

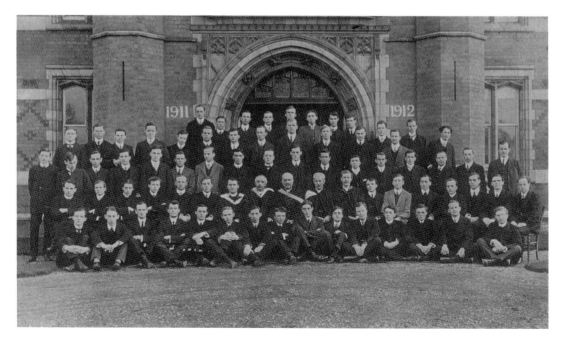

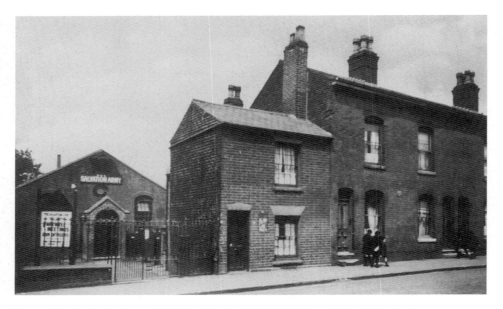

From a Methodist background, William Booth (1829-1912) founded the Salvation Army on military lines (1865). The 'Sally Army' became a much-loved and greatly respected institution carrying out onerous social work, alleviating, in practical ways, the plight of the underdogs in society. There is no trace of military pomp about this modest building in Nursery Road. With the small lettering on the noticeboard unclear, it seems unwise to interpret 'Farewell Meetings Our Officers'.

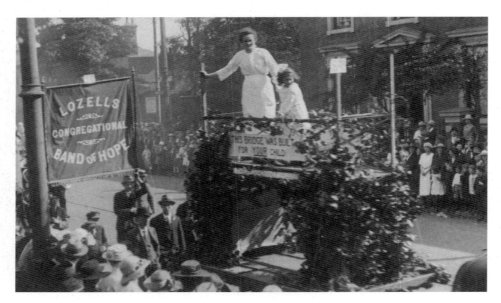

The message on this postcard's back reads: 'Sep 1921. This one speaks for itself, you see our banner waving well don't you.' The emphasis on the 'bridge's' banner 'Your Child' is significant. It is an allusion to the Band of Hope's purpose. This organisation, founded in 1855, promoted abstinence from alcohol, aiming especially at protecting children.

This card, written later in August, is addressed to 'Sister M. Magdalen, Maryvale Convent, Perry Barr, B'ham Local'. For reasons associated with its history, 'abbey' on the card was used as an alternative name for the Roman Catholic church built 1848-50 as the church of St Thomas and St Edmund. (Erdington.)

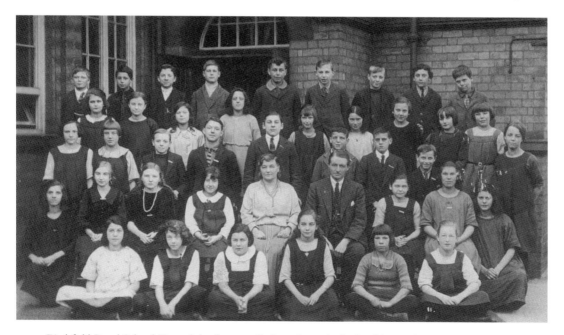

Birchfield Road School. To read the five pencilled words on the back of this card, a mirror is needed. An indecipherable word comes first, then 'Scool School Freda Young'. Are you on this 1924 photograph Freda? Situated near the Perry Barr railway station, this school opened in 1895, later re-organised several times. In 1945, the Senior Boys dept became a separate school. (Mirror writing was a cunning device for sending secret messages to classmates, something quite difficult to do with joined-up writing as Freda had found out.)

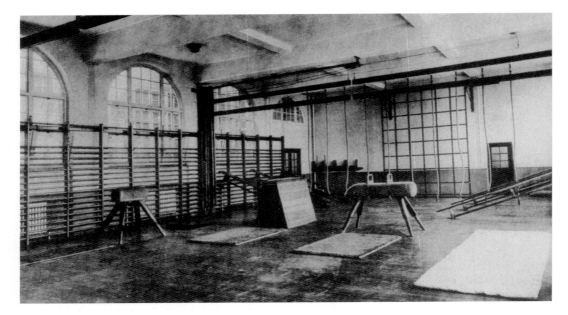

One of a series displaying the facilities of Saltley Secondary School. The gym apparatus shown on the card is typical of that to be found in schools fortunate enough to possess gymnasia in the 1930s – buck, box, vaulting horse, ropes, climbing frame, beams and parallel bars. It can be seen that the box is in sections so that its height, for vaults, can be adjusted.

Founded by the Bridge Trust in 1862, with fifty-nine pupils, Handsworth Grammar School for Boys is the nearer school on the card, postmarked 1928. In 1934 the author, in short trousers, entered this school, leaving in 1940, ready to join the Home Guard. Behind the No. 26 tram can be seen Grove Lane School, situated on the corner with Dawson Road. This school opened in 1903.

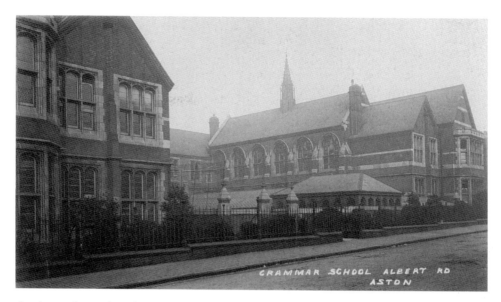

On the southern edge of Aston Park, this boys' school was one of the King Edward VI Foundation Grammar Schools in the city. The earliest and highest status one was established in New Street, see p.80. Aston Grammar was a rugby-playing school, yet one of its famous old boys, after serving as a lieutenant in the Royal Flying Corps during the First World War, made nearly 400 appearances for Aston Villa, one 'Dicky' York.

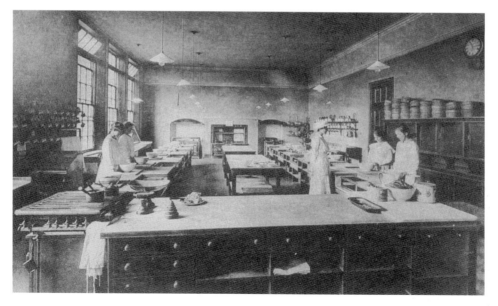

One of a dozen or so cards presumably issued to mark the opening of a 'new' King Edward's School for Girls, at Rosehill Road, Handsworth. Both the site and building were new, opening in 1911 with 450 pupil places. But as it had been formed from an amalgamation of three earlier King Edward's schools its centenary was celebrated in 1983. The card is of the 'Cookery Kitchen'. The gas stove seems sturdy enough to survive all manner of cookery triumphs and disasters!

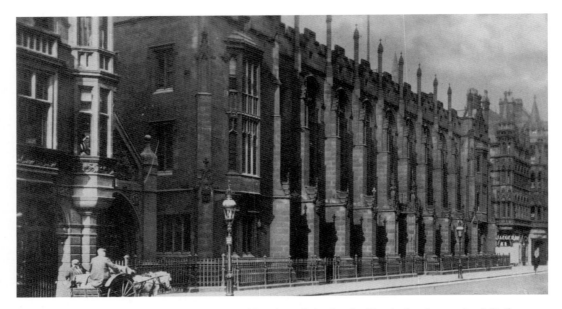

Above: King Edward's High School for Boys, widely acknowledged to be Birmingham's top school. Built in 1833, in the northern section of New Street, this handsome structure was designed by Sir Charles Barry, architect of the Palace of Westminster. When the school moved to Edgbaston in 1936 this building was demolished, being replaced by a cinema and stores.

Below: A fine overview of one of Britain's early 'redbrick' universities opened in 1909 by King Edward VII and Queen Alexandra. Sir Joseph Chamberlain, distinguished Birmingham MP and statesman, became the university's first chancellor. Many thousands of students came to know the clock tower as 'Joe', an affectionate tribute to the man. The university is situated on the Bristol Road, Edgbaston.

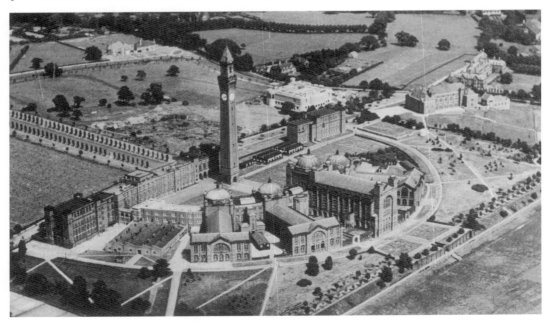

Right: Despite or even because of the growth of public education, private schools continued in business. The card bears Christmas greetings, the first Christmas of the First World War, 1914. Near Six Ways, Aston, a Hazeldene Grove is listed. A possible spelling error by a pupil, or the photographer, who had written Hazeldine.

Below: From its early Victorian beginnings this hospital, reflecting health conditions of the day, mutated from dealing with smallpox to handling scarlet fever epidemics, eventually becoming a general hospital. The tower block shown here was built in 1863.

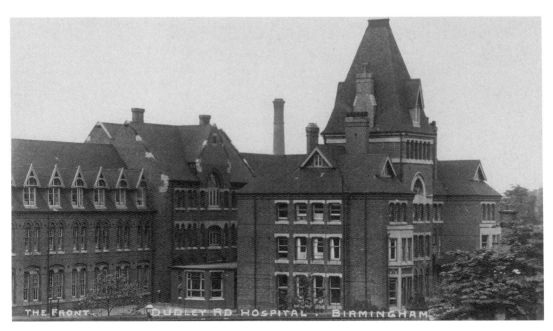

THE FRONT. DUDLEY RD HOSPITAL, BIRMINGHAM.

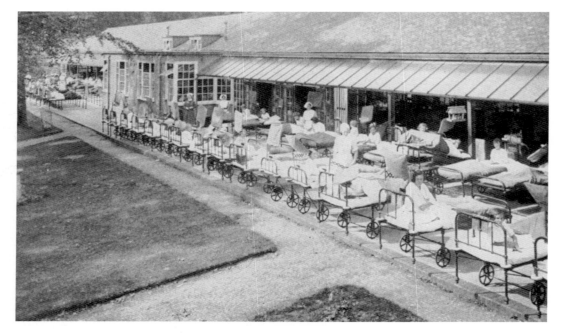

Above: Originally 'The Woodlands', a fine house set in extensive grounds, was the home of George Cadbury (of the chocolate-making family) who gifted the building to charity for conversion to a hospital for crippled children. This later became the Royal Orthopaedic Hospital. Illustrated is an open-air ward for TB patients. The bird table hanging from the edge of the roof may have been a mixed delight for the patient beneath! The hospital was located on the Bristol Road on the northern edge of Northfield.

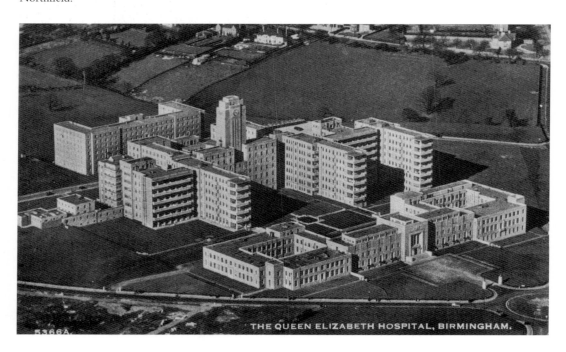

THE QUEEN ELIZABETH HOSPITAL, BIRMINGHAM.

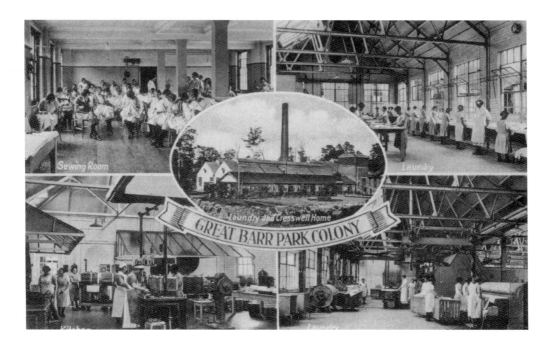

Sewing Room

Laundry

Laundry and Cresswell Home

GREAT BARR PARK COLONY

Kitchen

Laundry

Above: In the period under review, mental illness tended to be talked about in hushed tones and guarded manner. At Great Barr, where there still stood a mansion of some historic interest, its grounds were sold off in 1911. A large crescent-shaped group of buildings was erected near to the hall. This development became St Margaret's Hospital which adopted a more enlightened approach than that generally prevailing to the treatment of mental illness. This card is one of a series.

Right: This plaque above the little patient's bed, hospital unknown, reads: 'King Edward's Grammar School for Girls (Handsworth) Cot Miss L.C. Brew M.A. Headmistress.'

Opposite below: The Cadbury family donated 150 acres of land for the building of this modern twentieth-century hospital. Situated near the university, the hospital was opened in 1938 by the Duke of Gloucester, the new Queen Elizabeth being unwell at the time.

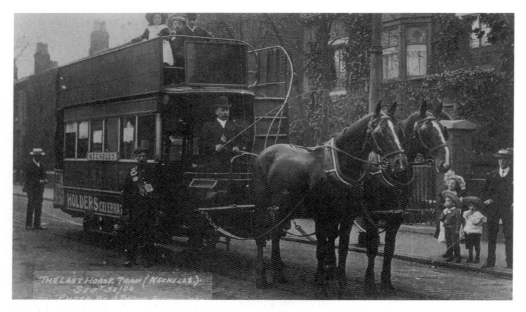

This card tells us that A. Twigg of Bloomsbury Street photographed this fine piece of nostalgia. Bloomsbury Street adjoins Nechells Park Road. The tram route was about two miles long between Albert Street, city centre and Butlin Street, Nechells. The occasion is dated on the card as 'Sept 30/00', a whole century before the millennium!

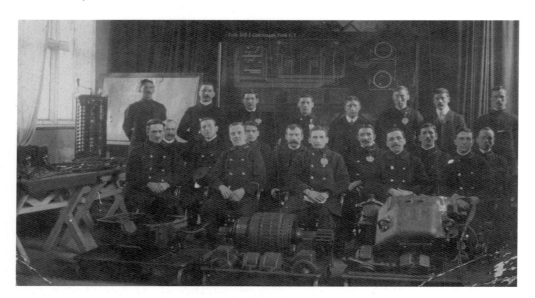

Initially, tramway services were provided by private companies but in 1904 Birmingham Corporation, empowered by law, took a hand and began to implement what became a first-rate municipal tramway system. Recruiting and training staff, especially drivers, became a key responsibility. The card states: 'Mr Woodman in Instruction School Moseley Depot'. The lettering on the large diagram at the back reads: 'Type DB 1 Controller Form G 1'. The controller was the unit by which the driver operated the tram from his platform.

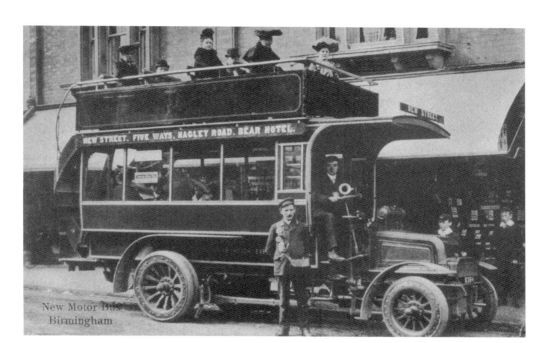

An early 'fairweather' bus – open staircase, open top, open to the elements driver, and conductor when not collecting fares inside. Given the route indicated, The Bear Hotel may be The Bear on Bearwood Road, Smethwick. The card is postmarked 1904.

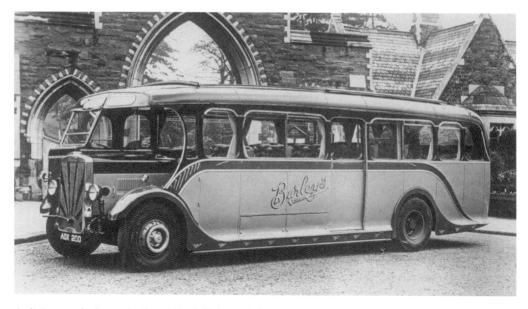

As living standards rose in the 1930s, half-day and day trips by coach became increasingly popular: trips to Matlock, Dovedale, parts of Wales for example. Burleys Garages operated from William Street, Lozells. The location chosen for this promotional card is somewhat peculiar, the coach being at rest outside an entrance to Witton Cemetery!

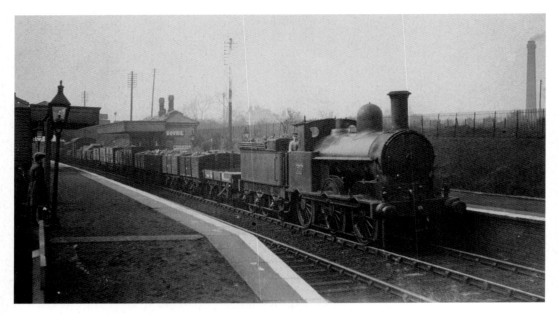

On the back of this card a railway buff cryptically reports as follows: '1259 LMS (LNW) May 1924 Up Goods Great Barr Station'.

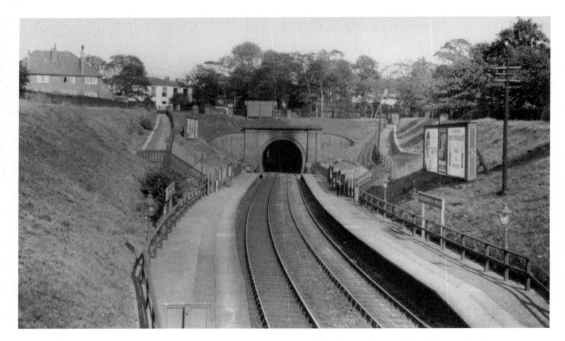

These railway lines passing through Handsworth Wood station bisect Handsworth Park by embankment and cutting and run north to Great Barr, north-east to Perry Barr and south to Soho Road. A narrow, Hamstead Road entrance to the park runs along the top of the bank above the hoardings. The three posters on the hoardings are not quite distinct enough to be identified. The short tunnel emerges briefly before diving under Wellington Road.

Sport and Recreation

With two stadiums for professional footballers and a county ground for cricket, Brummie spectators were well served (by the accommodation standards of the day), even if they sometimes went home disappointed by their teams' performances. The city generally was rich in football and cricket pitches. At the time war broke out in 1939 around 180 municipal football pitches and around 100 cricket pitches were available in parks and recreation grounds. Quite a number of large companies also had playing fields. By a combination of being given generous gifts of land, land leased at a token rent, and shrewd business sense, the Council acquired and developed many parks and open spaces in order to benefit Birmingham citizens. Four municipal, eighteen-hole golf courses were established and two of nine holes. Arrangements were put in place for the great fresh air lung of the Lickey Hills to remain accessible to the Birmingham public.

Previous page: This 'fine figure of a man' champion swimmer, E.H. Temme, a London insurance clerk, swam from Griz Nez to Dover on 5 August 1927 taking fourteen hours twenty-nine minutes. Seven years later he completed the double, swimming from England to France in fifteen hours fifty-four minutes.

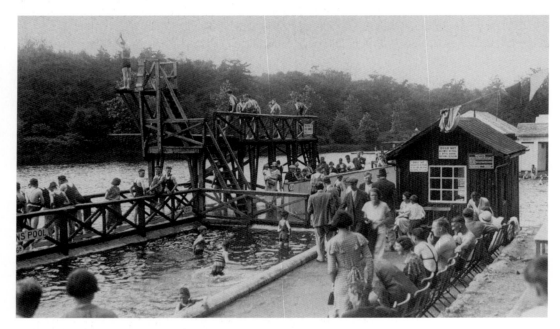

Above: We can never know or even reasonably guess how many youngsters were encouraged by E.H. Temme to improve their swimming abilities. But his appearance at this popular lido may well have been inspirational. To the right another pool is visible along with changing rooms. Notices make plain that dogs are not allowed in any of the pools.

Opposite below: Two professional teams in the city but dozens and dozens of amateur sides playing in various leagues in parks, public recreation grounds, private club pitches, works grounds *et al*. What might be lacking in goal nets and decent changing facilities was probably more than outweighed by energy and enthusiasm. This arms-folded photograph is typical of many of these real lovers of 'the beautiful game'.

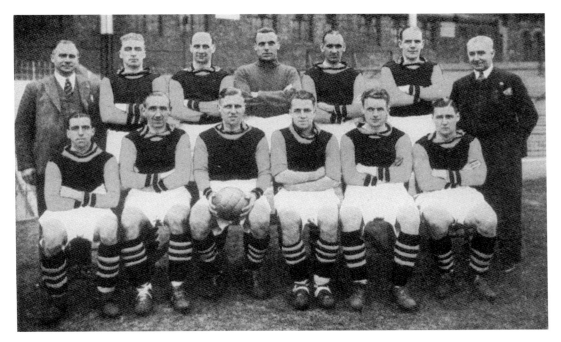

Above: Aston Villa (Villa Park) and Birmingham City (St Andrews, Small Heath) were Birmingham's two professional football clubs. Of the two, Aston Villa tended to attract the larger 'gates' and to win more trophies. This promotion-winning team consists of, back row: Bourne (trainer), Massie, Callaghan, Biddlestone, Iverson, Cummings, Hogan (manager). Front row: Broome, Haycock, Allen (captain), Shell, Starling, Houghton. (1938.)

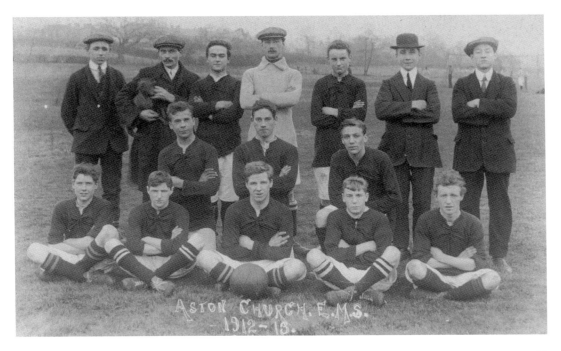

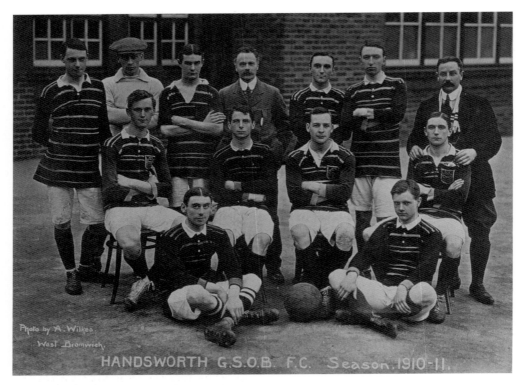

Photo by A. Wilkes.
West Bromwich.

HANDSWORTH G.S.O.B. F.C. Season 1910-11.

Above: Smart jerseys these, black with thin old gold stripes, for the most part worn outside longish knicks. This old club, still going, fielded several teams, playing their home matches on a triangular island of ground bordered by three sets of railway lines, two them mentioned on p.86.

Opposite below: All over town, scatterings of men (and maybe a girl or two) similar to this group stood about touchlines making a variety of cheering and/or derisory noises. Pipes, a fag, a hooter and cheerful smiles despite the heavy rain that has apparently fallen, given the state of their raincoats. Taken during the 1919/20 season, a Saltley connection of some kind? One enthusiast seems to be holding a bottle of embrocation (or tonic perhaps?) by the neck. Or just another hooter?

Right: 'Catch 'em young!' Although this photograph looks somewhat 'stagey', the injunction remains valid. The boy is holding a copy of the *Sports Argus* (founded 1897), perhaps the most intensely read of Birmingham newspapers. It appeared on Saturday evenings and contained hundreds of sporting results of events major and many minor, like games played in the parks. Although not used pejoratively at the time, many amateur football teams played in the 'Nig Nog League', formed by a charity which supported summer trips for children and free seats at the pictures. This lad seems to be from an economically comfortable home – note the fine rocking horse.

Below: As with amateur football, so with amateur cricket, if on a much smaller scale. On the card's back is written: 'Weslyen Cricket Club Nechells'. Presumably the lady was the scorer.

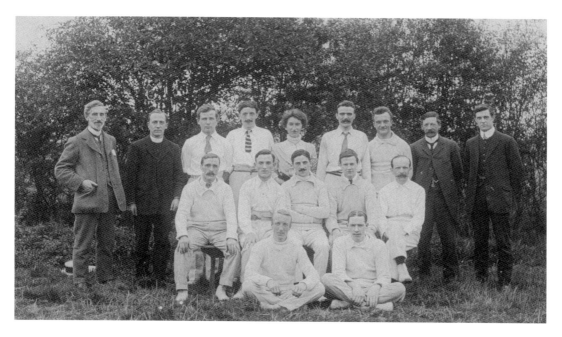

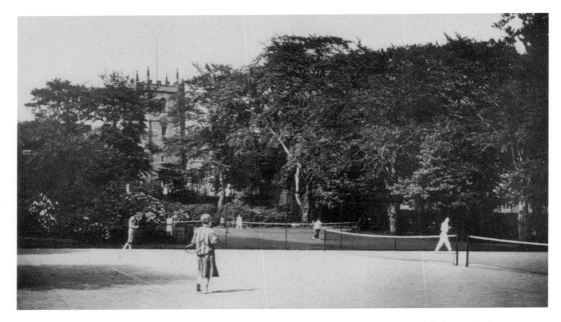

Handsworth Park. Tennis played in public parks and private clubs received an appreciable boost during the 1930s when Fred Perry won three Wimbledon singles titles on the trot and Dorothy Round, after years of near misses, won the Wimbledon singles final in 1937. Perry also won three USA titles and the French and Australian championships before becoming one of the early professional players.

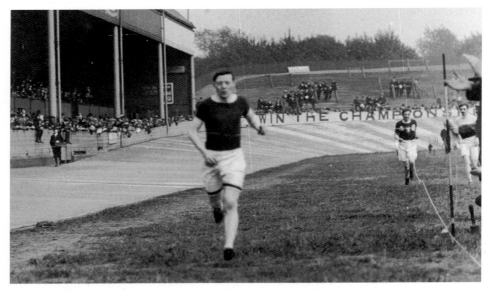

Running, track and field was a popular sport in the city. Large athletics events were often held at the sports grounds of major companies, e.g. Lucas's at Perry Barr, Cadburys at Bournville, as well as at club grounds such as the Birchfield Harriers' Alexander stadium, also at Perry Barr. A Bordesley Green photographer produced this card on the back of which is written 'Small Heath Harriers'. Presumably the banking was for cycle racing.

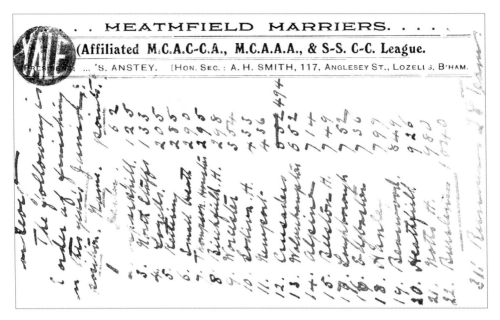

. . HEATHFIELD HARRIERS. . . .

(Affiliated M.C.A.C-C.A., M.C.A.A.A., & S-S. C-C. League.

PRESIDENT: ... 'S. ANSTEY. [HON. SEC.: A. H. SMITH, 117, ANGLESEY ST., LOZELLS, B'HAM.

Posted in Handsworth on 5 February 1907, this card provides evidence of the interest shown in junior athletics in the Midlands generally and Birmingham in particular. Seven Birmingham clubs feature in the lists. The other side of the card tells us that the race, presumably cross-country, was run on Derby racecourse, six men to a team. The first man home for Heathfield Harriers, P.M. Turner, came seventeenth. Tot up the positions of the six-man team – 926 – twentieth position for the club, as shown.

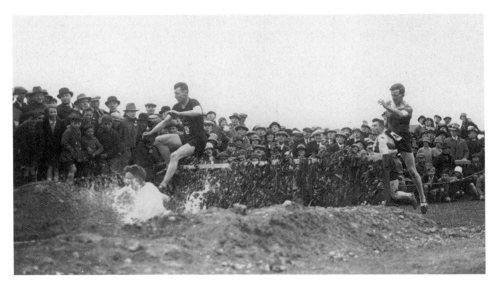

The card gives these details: 'Midland Counties A.A.A. Championships at Birmingham Gas Department Ground, Erdington June 15 1929. The 2 Mile Steeplechase No.5 J.E. Webster – Birchfield H.J.T. Holden Tipton SG W Part (?) Sparkhill'. Webster and Holden were star club runners of international calibre.

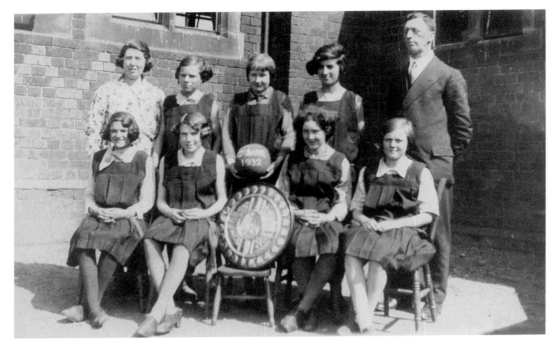

A self-evidently successful netball team, Great Barr, 1932. For the 'unenlightened', '...usually played outdoors and almost exclusively by girls and women, mainly in the UK and Commonwealth countries.' Issues to ponder there. 'Only the goal-shooter (GS) and goal-attack (GA) may shoot at goal.' Played seven a side on a court 100' x 50' divided into three equal areas, the goal an open net on a 10ft-high pole, shooting circle 16' in radius.

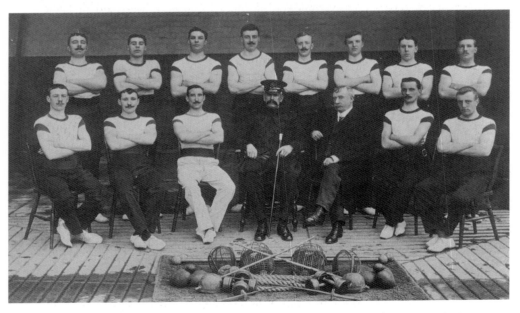

Birmingham City Police. A refreshing change from truncheon drill – and much more sporting?

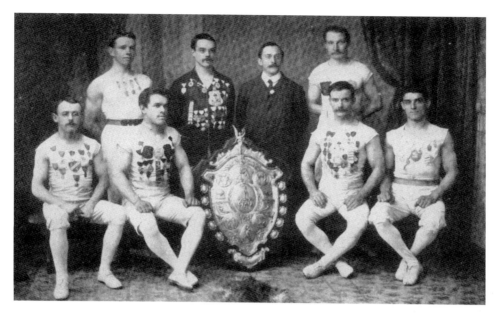

Birmingham Dolobran Atheletic teams. More successes, individual and collective. The Adams Shield displays interesting representations of various athletic/gymnastic activities. These appear to be, anti-clockwise from top centre: wrestling, boxing (a right cross to the chin), a vault, two men with weights?, discus thrower, two-men-handstands on parallel bars, a swimmer – swallow dive, two men fencing? Centre piece: eight (?) men forming a human pyramid three men high.

A more modest success – Birmingham and District. In fact, more modest in every way. The card gives the names of all those present including the pianist A.W. Cooke. (Junior Girls team.)

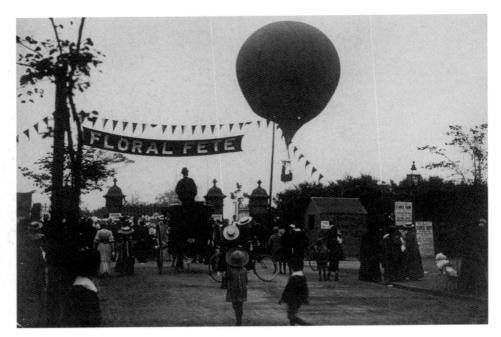

Before cars and charas took people to pastures new, Brummies made considerable and appreciative use of municipal parks. Victoria Park, Handsworth held an annual flower show and 'this' year the manned balloon flight pulled in the crowds. The balloonist may well have been a local resident, one George Lempriere (of French descent) who lived nearby in Wilton Road. He was adept in taking a paying passenger above the masses. George lived to be ninety-three and claimed to have carried more than 1,200 passengers on balloon flights during his long life without a single fatal accident. The way people are dressed and the presence of a Hansom cab point to this photograph having been taken pre-First World War.

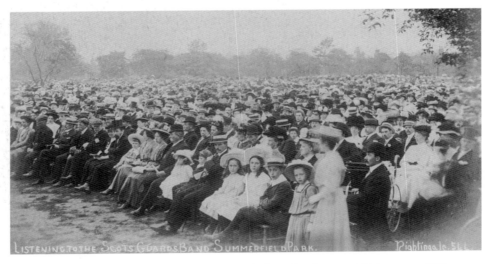

'Oh, listen to the band', in Summerfield Park, on the boundary between Edgbaston and Winson Green, everyone present in their Sunday best.

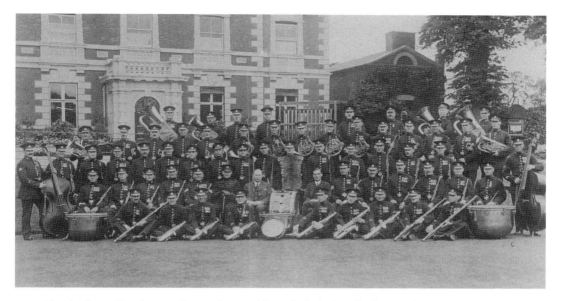

Not the Scots Guards as on the previous card but a hefty body of hefty men for all that: the Birmingham City Police Band. Probably they could not all sit together on a park's grandstand but doubtless a selected number of them would entertain at any one time.

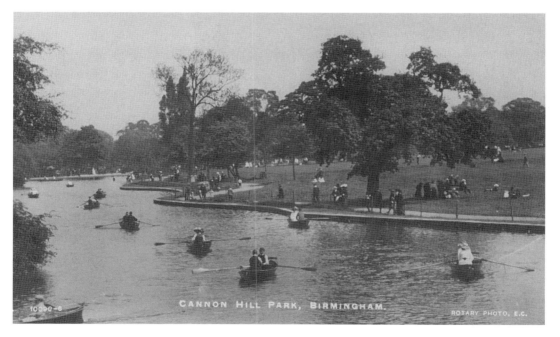

CANNON HILL PARK, BIRMINGHAM.

A number of Birmingham parks offered boating facilities: rowing boats, sometimes skiffs or canoes could be hired at so much per hour or half hour. Parks also provided sets of swings, separate for boys and girls, iron and wood roundabouts, tennis courts, bowling greens, putting greens, refreshment rooms and, inevitably, discreetly placed public conveniences. Cannon Hill and Handsworth were Birmingham's star parks.

COLLINS V PALMER GLADSTONE LEAGUE-FETE ASTON PARK 1914

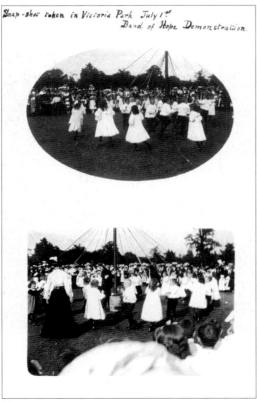

Snap-shot taken in Victoria Park July 1st
Band of Hope Demonstration.

Above: A high-level, open-air, good-natured pillow fight? The contest has certainly attracted a sizeable and amused crowd of spectators. Conceivably, the Gladstone reference concerns the great Victorian Liberal statesman and four-times prime minister. But Gladstone died in 1898. Perhaps the League had been founded to honour his memory and to promote the social and political reforms Gladstone had espoused.

Left: Written from Sparkhill on 22 August 1906: 'Dear Dorothy, I am sending the P/card as promised... Do you recognise the back view ... from Lottie.' Obviously written by an adult, Lottie must be the lady, in floor-length skirt, in the lower picture. As mentioned earlier, the Band of Hope was a temperance organisation concerned with child welfare.

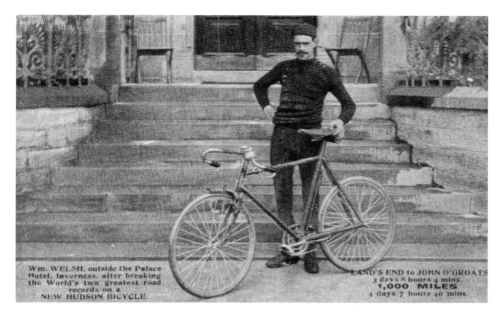

Wm. WELSH, outside the Palace
Hotel, Inverness, after breaking
the World's two greatest road
records on a
NEW HUDSON BICYCLE.

LAND'S END to JOHN O'GROATS
3 days 8 hours 4 mins.
1,000 MILES
4 days 7 hours 40 mins.

The Birmingham factories of the New Hudson Co. (founded 1885) manufactured most of their own bicycle components. The extent to which Mr Welsh's remarkable rides boosted sales is unknown. Although cycle clubs were formed for sport and recreation, the greatest total mileage pedalled was probably carried out by individuals who cycled to work and back every day.

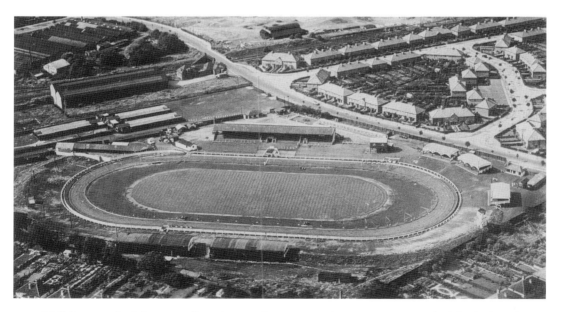

Hall Green evolved from a small rural area to become a modern, attractive green-leafed suburb with a high proportion of owner/occupier housing. Although carefully sited, a greyhound racing track in this part of Birmingham seemed a little out of character, unlike the track at Perry Barr. But if north Birmingham could have a dog track, why not the south?

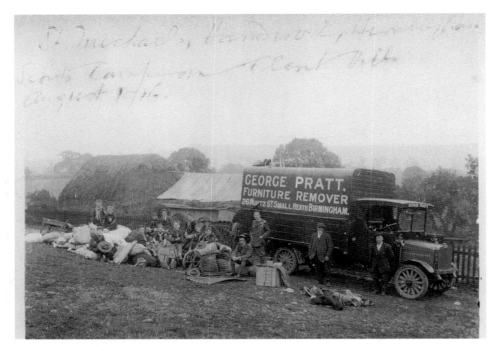

Scrawled on the front of this card, in ink: 'St Michael's, Handsworth, Birmingham Scouts Camp, Clent Hills, August 10/16. Our arrival – the advance party.' St Michael's church was situated near the top of Soho Hill. In this advance party there appear to be about a dozen or so Scouts, a couple of Scout Masters and two drivers. Scouts have to be prepared to 'Be prepared'!

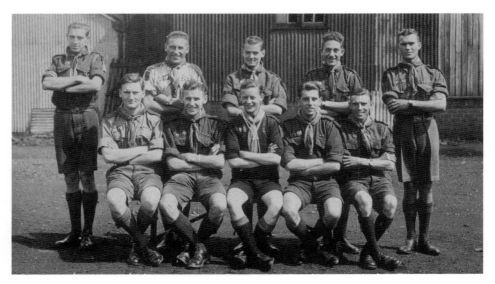

Baden-Powell, former distinguished general, founded the Boy Scout movement in 1908, and his sister the Girl Guide organisation. Both youth movements flourished, becoming international in scope. The senior Scouts from the Lickeys shown here may well have been taking part in some international exchange scheme.

eight

Recreation
and
Entertainment

A lthough a highly industrialised city, Birmingham did not lack citizens who were keen to promote the arts and to share their own enjoyment with others. Sir Barry Jackson and Dr Adrian Boult exemplify this desire (see below). The City Museum and Art Gallery opened in 1885, the Barber Institute of Fine Arts in 1939, and, of course, Aston Hall had long been a source of interest. While theatres had their regular patrons, their numbers greatly increasing during the panto season, mass entertainment was principally provided by the cinema and the radio. It has been estimated that by 1939, three out of four British households had a radio. The man-in-the-street could not only tune in to the BBC but to Radio Normandy with its light entertainment programmes interspersed with advertising plugs.

Previous page: Whatever the 'Dainty Waltz' had been, it was probably forgotten by the 'roaring 1920s' when short-skirted flappers and the Charleston were all the rage. During the 1930s, thanks largely to radio broadcasts, gramophone records and the formation of many dance bands, ballroom dancing in all manner of locations, additional to ballrooms, enjoyed its golden age, being an extremely popular recreation.

Left: Although there is no specific connection between this card and Birmingham, it does display one of the most historic adverts ever devised, the iconic 'Nipper' listening to HMV. Many such records were played and danced to in homes, church halls and community halls in the city.

Opposite above: Widely regarded as Birmingham's premier theatre, the Theatre Royal experienced a long history. Opened in 1774, it was rebuilt twice after disastrous fires and handsomely renovated during 1902-04. Usually more serious-minded than the card would suggest, this New Street theatre attracted top actors and staged classic plays. Other city centre theatres included The Prince of Wales and The Alexandra. The Birmingham Repertory Theatre founded in 1913 enjoyed nationwide acclaim under the inspired leadership of Sir Barry Jackson.

THEATRE ROYAL.
BIRMINGHAM.
APRIL 18th, 1910. SIX NIGHTS.
MATINEE, THURSDAY.

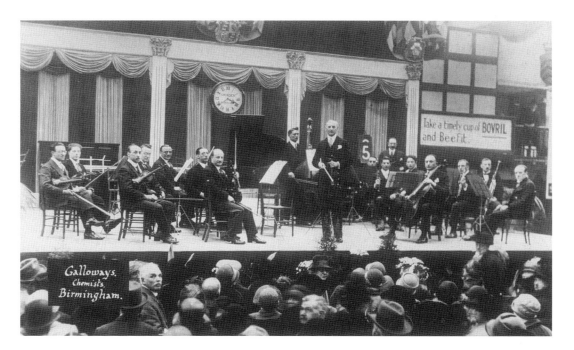

An afternoon concert, note the clock, at what could be a trade fair. Galloways may have sponsored the all-male orchestra's appearance. The city's 'official' orchestra (The CBSO) was founded in 1920 and from 1924 until 1930 it was conducted by Sir Adrian Boult.

Above: This cinema opened in 1913 to seat and entertain nearly 1,000 patrons. Although silent, moving picture shows were extremely popular, representing a major and relatively cheap advance in mass entertainment. This programme was for Easter week, 1917. Two serials are included, one 'great', the other 'sensational'. Such 'cliffhangers' attracted picturegoers to return again and again and occasioned much discussion along the lines of 'will she, won't she?'. As early as 1914 fifty-three cinemas were open in the city.

Left: Dubbed 'the serial Queen', Pearl White (1892-1938) was rescued numerous times from the caddish advances of moustachioed villains and life-threatening situations like being tied across railway lines as the train thundered towards her. The pianist or small musical ensemble present would excite the audience with appropriate accompaniments.

Opposite below: Birmingham's most popular fair was held annually on the Serpentine Ground, Witton – the obscurely named 'Onion Fair'. Here is a 1907 version of the universal conception of a merry-go-round.

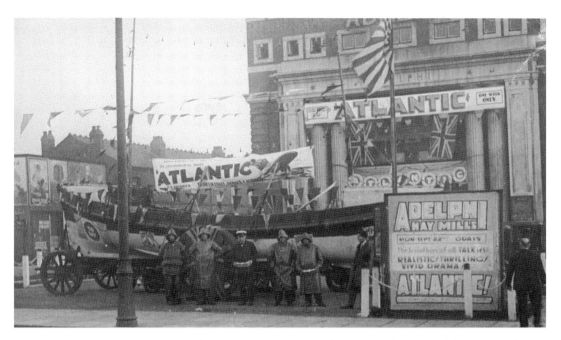

Above: Once 'talkies' had successfully arrived, cinema-going boomed. As this new 'Adelphi', opened in 1929, a considerable publicity splash was made to attract full houses. The smaller print on the hoarding reads: 'The Leviathan of all TALKIES, REALISTIC THRILLING VIVID DRAMA.' Gee Whiz! This British film had been produced in 1929 and was probably chosen to mark the new cinema's opening. This was the first British film to have French and German soundtracks for export purposes.

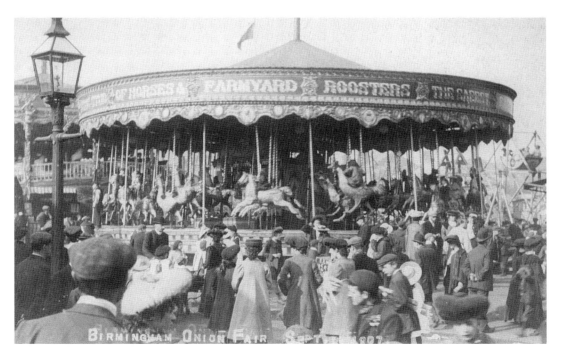

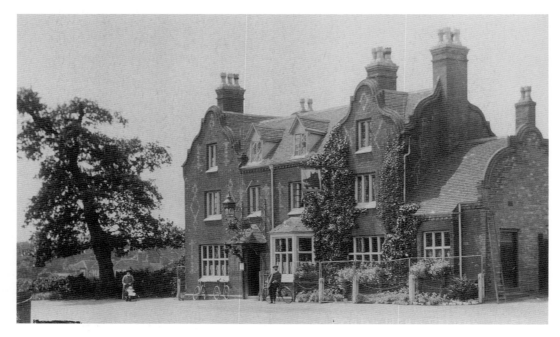

Like most towns and cities in Britain, Birmingham experienced no dearth of pubs. When this card was sent in 1912, Perry Barr was still quite rural. The Boars Head, of pleasing design and styled a hotel, is adjacent to Perry Park. A large inn sign juts out from the ivy.

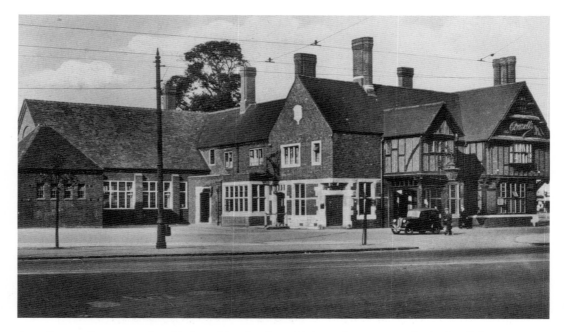

A roadhouse of a more modern kind, capable of coping with increasing motor traffic. An Ansells house, strategically sited at the terminus of the No. 10 tram service, 'Martineau Street to Washwood Heath (Fox and Goose)' one of two pubs to be cited in the Corporation's list of tram services in 1937.

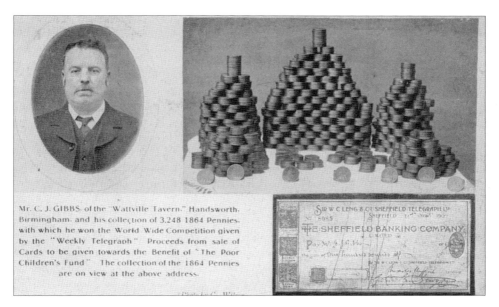

Mr. C. J. GIBBS, of the "Wattville Tavern," Handsworth,
Birmingham, and his collection of 3,248 1864 Pennies,
with which he won the World Wide Competition given
by the "Weekly Telegraph." Proceeds from sale of
Cards to be given towards the Benefit of "The Poor
Children's Fund." The collection of the 1864 Pennies
are on view at the above address.

The pub good cause practice of building a pile of coins on the bar counter is clearly an established one. Research indicates that the 1864 penny carried no more than its face value. The cheque, made out to Mr C.J. Gibbs, is for £100. 3,248 pennies at 240 to the £1 equals £13 10s 8d. Wattville Road, a tribute to James Watt, is in the Soho Road area of Birmingham.

Probably a card produced just for this group, the line at the bottom reading: 'B'gh'm Gas Co. Perry Bar. 4.7.36 no 30.' The occasion could be a works outing possibly into Gloucestershire, the professional photographer giving a Tewkesbury address. The flared trousers worn by some of the men are reminiscent of an earlier fashion, Oxford bags.

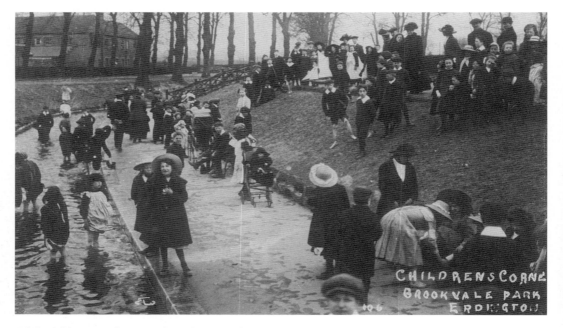

While children are adept at making their own fun, they can be helped, as here, by facilities set aside for them. The card is postmarked October 1916. At the top of the bank some lucky youngster/s is holding tight to an impressive toy yacht. An extensive boating pool adjoined this stream.

'Race yer to the 'orse and cart!' Future harriers for Birchfield, Lozells, and Small Heath clubs? The so-called Boulevard was a short stretch of dual carriageway at the northern end of Grove Lane. The No. 26 tram route, from Oxhill Road to the city, passed either side of the tree-lined central strip of land.

nine

Wartime

For over a quarter of the period 1900-1945 Britain was at war: with the Boers in South Africa and twice with Germany and her allies. In both world wars, one of the grim paradoxes of war was starkly realised: war creates jobs, improves pay, yet slaughters people in their millions. Both the First and Second World Wars witnessed Birmingham intensively engaged in the production of arms and ammunition. The Second World War brought a new factor into play, civil defence to counter the Blitz from the air. In Birmingham, in addition to surface and basement shelters, 152,000 Anderson shelters and 24,000 Morrison shelters were supplied to householders. Some 1,100 houses were seriously damaged by enemy action. Over 127,000 houses needed some repairs due to bomb damage. Parks and open spaces provided sites for ack–ack guns, barrage balloon units, ARP posts – and land for wheat, rye and potato crops.

Previous page: It is uncertain whether this patriotic display marks the end of the First or Second World Wars. It can well serve for both victories. Thought to be a shop in Hall Green.

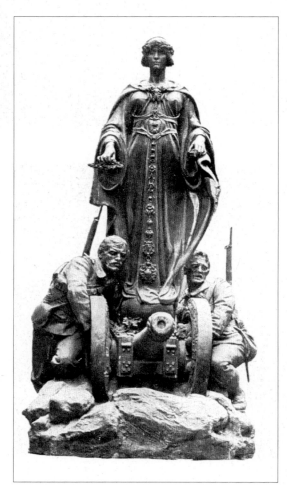

Left: Whatever the rights and wrongs of the Second Boer War, 1899-1902, fought over the degree of independence to be allowed to South Africa by Britain, the one certainty was casualties on the battlefield. This statue serves as a large finial to the much larger monument on which it stands. The noted sculptor later sculpted the statue of King Edward VII to stand outside the Council House.

Opposite above: Postmarked 23 October 1915, this card provides evidence of how quickly and capably women took on the jobs of men who had been sent to 'the Front'. Eveline writes to her friend Edith: 'Sorry I cannot come tonight but I am on duty till 12 o'clock.' All the ladies appear to be conductresses as each carries a small satchel for customer fare money and change. In two cases ticket punches are visible.

Opposite below: On the back of the card is scribbled 'Hockly Goods GWR 1916'. There was a railway station at Hockley. Research suggests that the ladies in peaked caps are railway workers while those in round hats are members of the WAAC, the Women's Army Auxiliary Corps, established by the government in 1916. Volunteers were sought 'To Work at Home and Abroad with the Forces' and to carry out a variety of civilian jobs. By the war's end nearly 60,000 women had served in the corps.

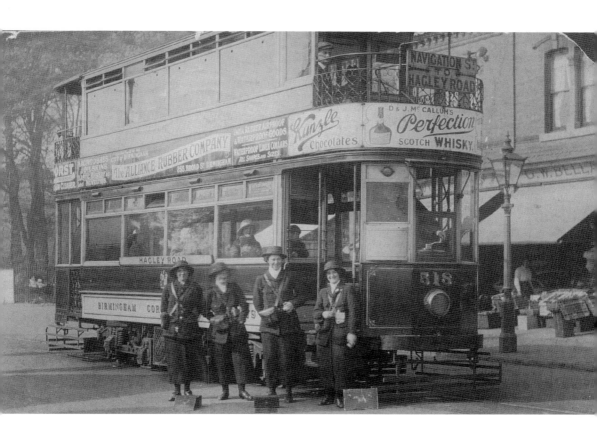

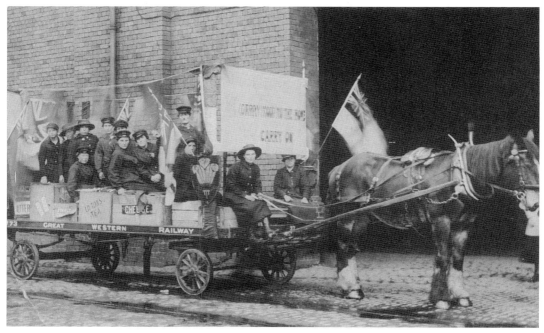

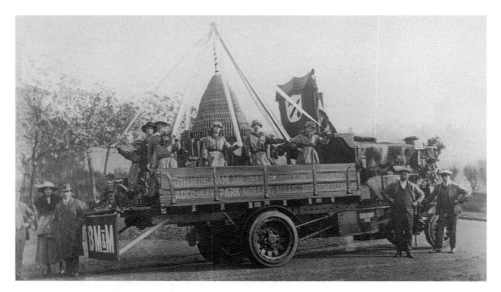

By July 1917, 819,000 women in Britain were working on munitions, compared to 212 in July 1914. Here are a few of those ladies. The Birmingham firm can be made out on the side of the lorry as can its location. The writer states '...this is one of our carts win the war day.'

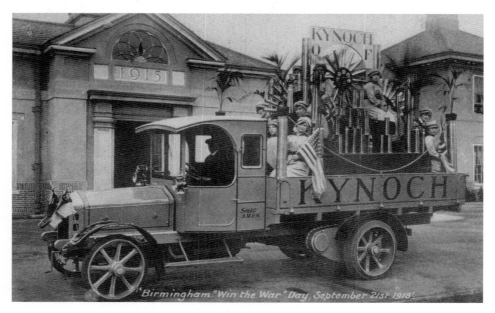

In 1915, in order to drive up production, the dynamic Lloyd-George was appointed the first head of the Ministry of Munitions. At the time of this display, Lloyd-George was prime minister and Armistice Day was just two months away. This card is one of several showing other floats with the same theme. Women munition workers were paid good wages, and received cheap but satisfactory meals in factory canteens. These experiences increased their sense of independence and fuelled support for the vote. Incidentally, a popular item on canteen menus was 'Two Zepps in a Cloud' (bangers and mash).

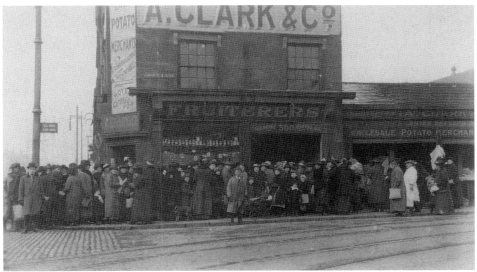

Top: A wartime visit which would mean a great deal to Kynochs' workers, gripped with patriotic fervour. King George V's son, King George VI, repeated the visit during the Second World War when the popular mood was more one of seeing that a necessary but dirty job 'got done'. Note the spats on the card – a fashion statement abandoned well before 1939.

Above and right: Judging by the murky atmosphere and the clothing worn, this was a day of raw cold as people queued for potatoes in 1917 at the potato merchants at the corner of Grove Lane and Soho Road, Handsworth. When spuds are in short supply, a nation knows it's up against it.

THE END OF A PERFECT DAY.

By I. M. RICKARD,
Hamstead Hall,
March, 1918. Handsworth.
Munition Worker.

When you come to the end of a pot of jam
And you haven't a slice of bread,
When you think of the dear old eggs and ham,
Don't you wish that you were dead?
And when we're travelling home at night,
To sit by the fire with ease,
Don't you long for a bite—a dear old bite
Of some good old-fashioned cheese?

Then in the morning, when you rise
To take a slight repast,
On a dainty plate before your eyes
Dear "Margie" sticketh fast.
She seems to be imploring you
To taste well of her store.
There is but one chance left for you,
Please do not ask for more!

We're working on Munitions,
Of that there is no doubt.
We stand in queues for rations,
While the Germans starve us out.
Queues for butter, queues for bacon,
Queues for tea and margarine,
From early morn to late at night
This sight will oft be seen.

In a long, long queue to the butcher
Or to the corner pub,
While our men are fighting for VICTORY
Our women are fighting for "GRUB."
But still we go on smiling,
Tho' our hearts be rent in twain,
We'll keep the home fires burning
Till the boys come back again.

Proceeds in aid of blinded soldiers.

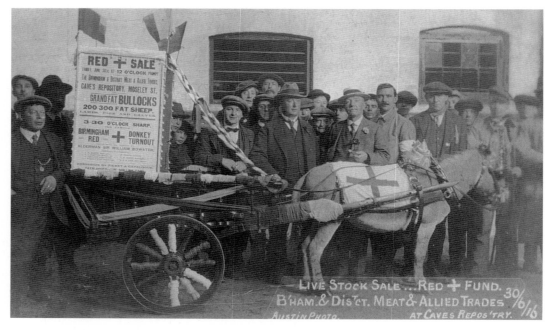

The Red Cross, an international organisation, was formed to alleviate human suffering. The British Red Cross did valiant work during the First World War, especially in caring for the wounded. The card shows an example of their fund-raising activities. Clearly grass was not rationed as both bullocks and sheep are claimed to be 'fat'!

Postmarked 1915. The word scratched out between 'Hollymoor' and 'Northfield' is 'Asylum'. General hospitals were unable to cope with the relentless flow of casualties, especially from the Western Front. The first Birmingham war hospital was Rubery Hill, in the same vicinity and also a defined lunatic asylum. An indirect comment on the madness of war? Not then, but later.

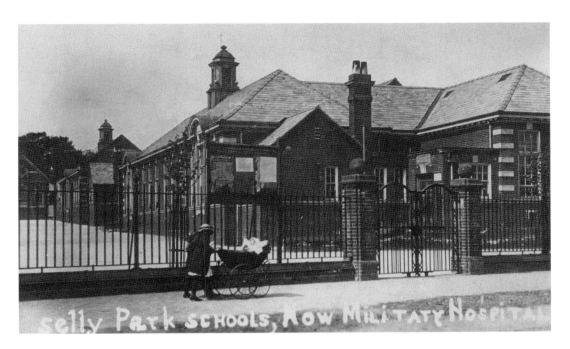

Selly Park Schools, now Military Hospital

Above: Ken writes on 4/1/18: 'Stirchley Section, (formerly Selly Park Council School) 1st Southern General Hospital, Birmingham, England. There are three "wings" (or "blocks"), each containing 7 or 8 wards. The whole section will accommodate over 300 patients. Our block ("B") was formerly occupied by girl-pupils of Selly Park School.'

Right: The two men whose backs are propped against the stage are probably in the category of 'walking wounded'.

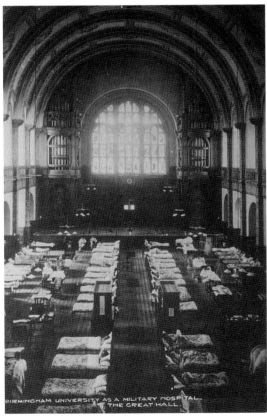

BIRMINGHAM UNIVERSITY AS A MILITARY HOSPITAL.
THE GREAT HALL.

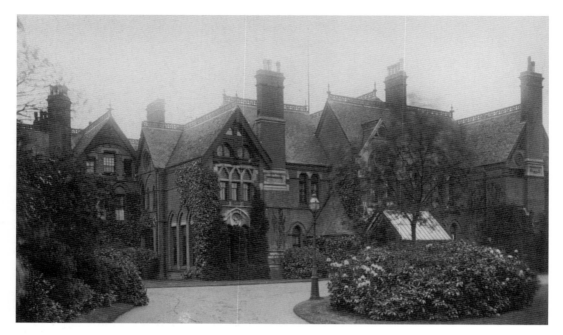

Above: Joseph Chamberlain, whose home this was, died in 1914 and his family allowed the house to be used as a VAD military hospital. Later it became a home for disabled ex-servicemen. VAD stands for Voluntary Aid Detachment, an organisation established by the government in 1909. The responsibility for its operation was taken over by the British Red Cross in 1911. Women volunteers served as nurses, cooks, laundresses, maids, clerks and drivers. From as early as October 1914 VAD personnel were closely involved in the rapid and essential conversion of all manner of non-hospital buildings into efficient temporary hospitals.

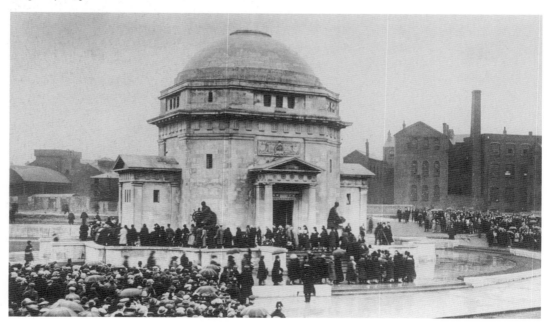

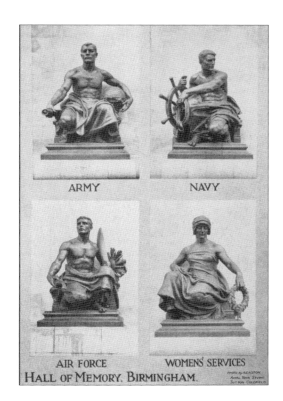

ARMY NAVY

AIR FORCE WOMEN'S SERVICES

HALL OF MEMORY, BIRMINGHAM.

Two of these four bronze statues, sculpted by Albert Toft, can be seen on the previous card.

Right: There can hardly be a hamlet, village or town in Britain that has no memorial to honour its First World War dead. A Mrs Watson of Park Road, Aston wrote to a friend on 9 September 1921: '… this is a photo of the Cenotaph unveiled last Sunday, in Aston Churchyard.' The inscription reads: 'France, Italy, Belgium. To the Glorious Memory of the Officers, Warrant Officers, Non-Commissioned Officers and Men of the 8th Battalion The Royal Warwickshire Regiment, who laid down Their Lives in the Great War 1914-1919.' The future Field Marshal Montgomery (Monty of Alamein) served with the Warwickshire Regiment during the First World War.

Opposite below: 'Lest we forget'. Sited in Broad Street at one corner of the 'new civic centre' area, this Portland stone octagonal memorial was built during 1923-24.

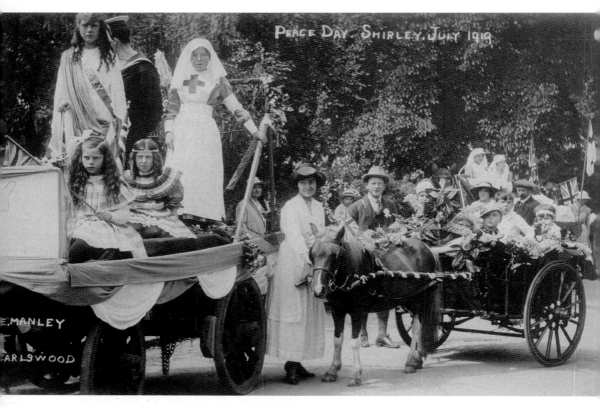

Peace Day, a few months on from when the guns fell silent on 11 November 1918. A day celebrated in a variety of joyful ways. The slightly apprehensive-looking girl is dressed to represent the Red Cross nursing organisation. At the time, Shirley was more rural than urban.

This Fort Dunlop pavilion was built not only to honour the dead but to help provide a better life for rising generations. Such an arrangement was adopted by other organisations including some churches which had halls built for social purposes – the staging of amateur dramatics, Beetle Drives, table tennis tournaments, Saturday night hops for ballroom dancing.

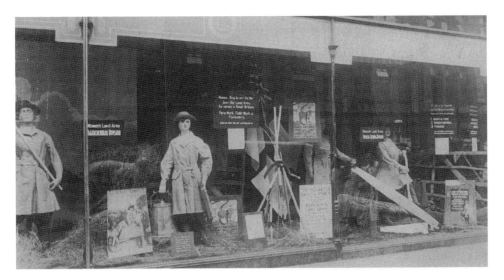

All too soon, Britain found itself recruiting for war once more in order to survive as a free nation. While this is a card from the First World War, it is equally relevant to the Second World War. Because U-boat action was seriously damaging Britain's food supplies, the government, in 1917, established the Women's Land Army. Hence this window display in Lewis's store in Birmingham. Quite a lot of information can be made out on the notices. Land girls were signed on from the beginning of the Second World War. But smocks were definitely 'out' and jerseys and baggier breeches very much 'in'.

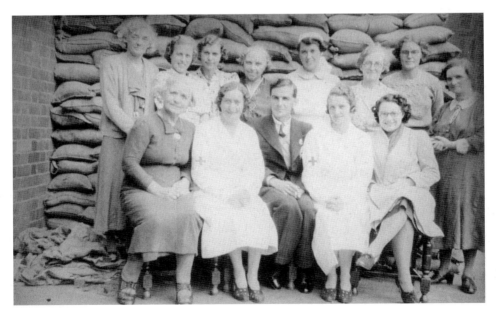

'Put me amongst the girls...' An old music hall song strikes a chord here. On the card's back: 'Aug 1939, Sparkhill TA Post, Sparkhill Baths.' TA usually meant Territorial Army. War was declared on 3 September but plenty of sandbags had long been in place. Two Red Cross nurses with identical pairs of shoes. Scope here for further research!

By the time this card's message was written, Birmingham had experienced quite a pasting from the Luftwaffe, which those present on the photograph had probably endured. 'To W.W. Small Esq., Divisional Warden Digbeth. With the Seasons Greetings and Best Wishes for a Bombless New Year From all at A6. B.T. Harcombe, Head Warden, Dec. 1942.'

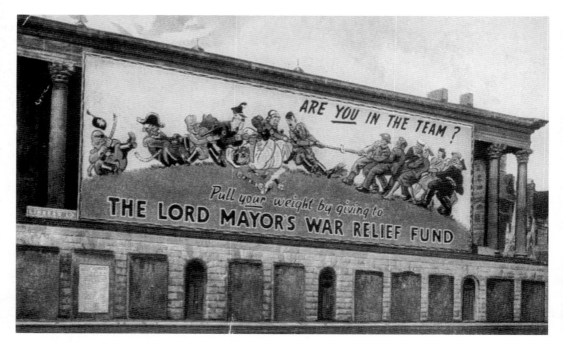

Postmarked 7 November 1944, this card reveals that Birmingham enterprise is alive and well. The back makes plain that Linread Ltd, Bolt, Screw and Rivet manufacturers, B'ham, paid for the Town Hall poster. The sender writes: 'You can see I am putting all my money into war saving...' All?

Celebrations and Public Events

In Britain, at the beginning of the twentieth century, few people would have claimed to be republicans. For the most part, the country was staunchly monarchist. Any official visit to Birmingham by one of the royal family was occasion not only for an impressive civic reception but jubilation on the streets. The same held true for the coronations of King George V and King George VI. In a way, Joseph Chamberlain was a 'king' among his many supporters and much of the public at large. Other politicians could attract large crowds but usually to mixed receptions. Crowds were also happy to turn out for the city's annual flower show, scouts' rally and, of course, the week-long celebration in 1938 of the city's centenary. The 'high jinks' included a pageant in Aston Park designed to demonstrate the city's history, the vast majority of the cast being ordinary Brummies proud of but not pompous about their home town's achievements.

Previous page: Here is the sculptor, previously mentioned, apparently putting the finishing touches to a very life-like statue that was to stand in Victoria Square.

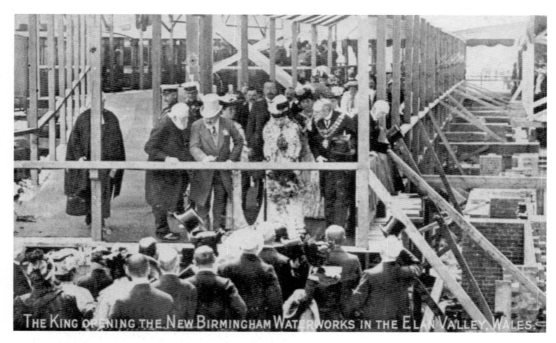

THE KING OPENING THE NEW BIRMINGHAM WATERWORKS IN THE ELAN VALLEY, WALES

Above: In the Elan valley region of Wales, some seventy-odd miles from the city, Birmingham Corporation had bought areas of land in order to ensure new and badly needed water supplies for the city. A massive dam and waterworks were constructed and in 1904 King Edward VII set the whole process in motion.

Opposite below: In 1906, the year of his re-election, Chamberlain celebrated thirty years service as an MP and his seventieth birthday. Many different postcards were produced to mark both occasions. A day was set aside for city-wide celebrations. A grand tea party, for selected guests, was held at Aston Hall. With his wife, Chamberlain toured the city to the enthusiastic cheers of large crowds.

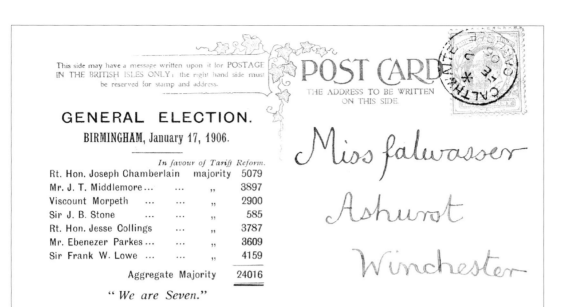

GENERAL ELECTION.

BIRMINGHAM, January 17, 1906.

	In favour of Tariff Reform.		
Rt. Hon. Joseph Chamberlain	majority		5079
Mr. J. T. Middlemore...	...	,,	3897
Viscount Morpeth	,,	2900
Sir J. B. Stone	,,	585
Rt. Hon. Jesse Collings	...	,,	3787
Mr. Ebenezer Parkes...	...	,,	3609
Sir Frank W. Lowe	,,	4159
	Aggregate Majority		24016

" We are Seven."

What Birmingham thinks to-day, the Empire will think to-morrow.

Miss *falwasser*
Ashurst
Winchester

Above: In 1906, for reasons intimated below, some postcard publishers must have enjoyed a bonanza year. The reference to 'Tariff Reform' reflects Joseph Chamberlain's passionate belief that the imports from the Empire should be given preferential treatment and taxes imposed on goods imported from elsewhere. For Chamberlain and his supporters, the prosperity of Britain was paramount. He believed that his policy would improve the lot of the man-in-the-street.

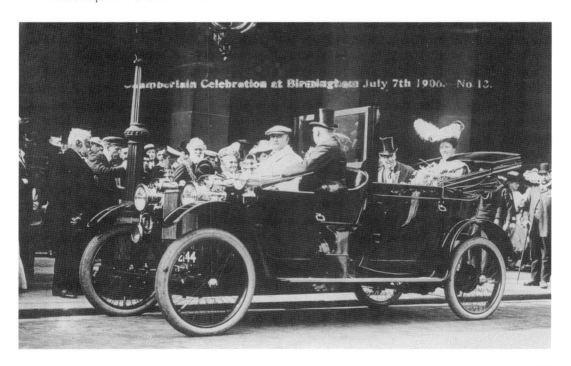

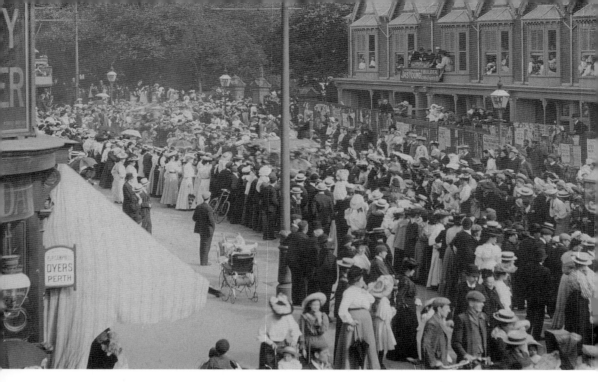

Above: One member of the crowd writes on this card: 'This is a view of the entrance to Small Heath Park on Chamberlain Day.' On a different card we read: 'Dear Edith ... there were grand doings that day, at all the parks, we got home at 11 o'clock from Handsworth; we-stayed to see the fireworks.'

There was a great civic to-do when King Edward VII and Queen Alexandra visited the city on 7 July 1909. Birmingham trade organisations donated triumphal arches erected along the royal route in the city centre. These elaborate and lavishly decorated structures left no doubt as to the identity of the donors, e.g. 'Loyal Greetings from the Metallic Bedstead Manufacturers' and 'the 'Cycle Trade Welcomes Your Majesties'. The royals had come to open Birmingham's spanking new university at Edgbaston.

Above: 'Long Live King George V' writes the sender of this card from Smethwick to Stockport on 14 May 1910.

Opposite below: This local celebration was of great importance to those who placed high value on 'book learning'. Years of local struggle were rewarded with success when Andrew Carnegie the Scottish/American multi-millionaire financed the building of Erdington Library, and others in Britain, from a fund he had established for the purpose.

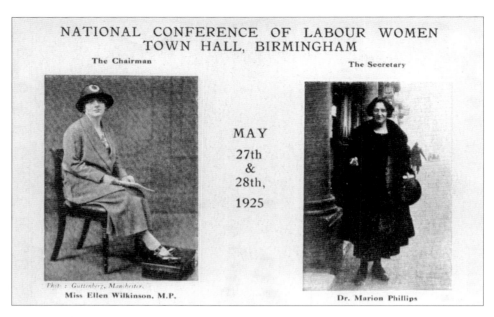

NATIONAL CONFERENCE OF LABOUR WOMEN
TOWN HALL, BIRMINGHAM

The Chairman

The Secretary

MAY
27th
&
28th,
1925

Photo : Guttenberg, Manchester.
Miss Ellen Wilkinson, M.P.

Dr. Marion Phillips

Ellen Wilkinson (1891-1947) was a prominent feminist and politician. Regarded in some quarters as a bit of a firebrand, she was first elected as an MP in 1924. In 1935 she was the member for Jarrow and was closely involved in the 'Jarrow Hunger March' of 1936 which focussed the country's attention on the dire plight of the shipbuilding unemployed. In the 1945 Labour Government she became the first woman to be appointed to the post of Minister of Education.

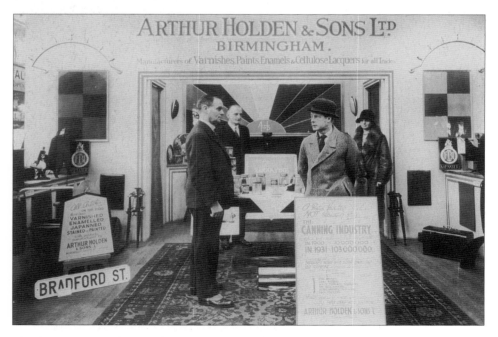

The future uncrowned King Edward VIII, presumably trying do his best to look interested at the 1932 British Industries Fair.

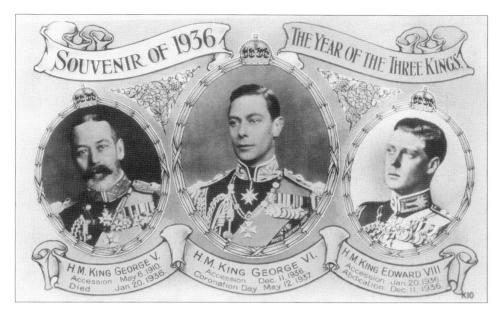

This card presents, in very crisp fashion, the essential facts regarding three kings who all reigned in a single year.

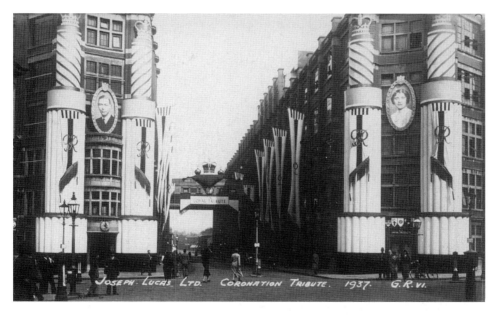

On the bridge that links the two parts of Birmingham's electrical engineering giant, is a banner proclaiming 'In Loyal Tribute'. Above the right-hand door and just beneath the shields can be read the exhortation to 'Buy British Products'. If the accession to the throne process had been 'untidy', there is a pleasing symmetry about the coronation decorations. The country at large was pleased and relieved that George rather than Edward had been landed with the job of reigning over us, including schoolchildren who had been given a day off on Coronation Day.

Other local titles published by Tempus

Birmingham: The Building of a City

JOSEPH MCKENNA

Since the time of William Hutton's history of Birmingham in 1780, there has been no real attempt to describe and explain the physical growth of Birmingham as a city and to consider why it developed in the way it did. When was the growth and why did it occur? What created the city street plans we see today? Who were the men who designed, financed and built modern Birmingham? This fascinating book provides answers to these important questions and more.

0-7524-3489-6

Haunted Birmingham

ARTHUR SMITH AND RACHEL BANNISTER

From creepy accounts of the city centre to phantoms of the theatre, haunted pubs and hospitals, Haunted Birmingham contains a chilling range of ghostly phenomena. Drawing on historical and contemporary sources, you will hear about the landlady who haunts the site of her death, the two workmen who died during the building of the Town Hall, the late mayor who still watches over the city, the last man to be publicly hanged in Birmingham, and many more ghostly goings on.

0-7524-4017-9

Selly Oak and Selly Park

J. BUTLER, A. BAKER AND P. SOUTHWORTH

This timely record of Selly Oak and Selly Park – compiled by members of the Selly Park Local History Group – forms a pictorial history of Selly Oak over the last century. From the mid-twentieth century, as older industries declined, the impact of the expanding university has been increasingly felt and the twenty-first century will bring further changes.

0-7524-3625-2

Central Birmingham Pubs

JOSEPH MCKENNA

This fascinating volume records the pubs, inns, taverns and beerhouses of the central city, an area now within the present Inner Ring Road and the Bull Ring. This is the very heart of the city and although it comprises only one square mile and can be crossed by foot in less than half an hour, it is an area that has seen over 760 pubs – all of which are faithfully recorded here.

0-7524-3873-5

If you are interested in purchasing other books published by Tempus, or in case you have difficulty finding any Tempus books in your local bookshop, you can also place orders directly through our website

www.tempus-publishing.com